CREATURES OF CLAY

and Other Stories of the Macabre

by

Stephen Sennitt

DIAGONAL

an imprint of headpress

A Diagonal Book
Published in 2003
by Headpress

Headpress / Diagonal
PO Box 26
Manchester
M26 1PQ
Great Britain

Tel / Fax: +44 (0)161 796 1935
Email: info.headpress@zen.co.uk
Web: www.headpress.com

**British Library Cataloguing in
Publication Data**
A catalogue record for this book is
available from the British Library

Printed and bound by The Bath Press

ISBN 1-900486-25-3

**Creatures of Clay
and other stories of
the macabre**

Text copyright © Stephen Sennitt
This volume copyright © 2003
Headpress
Cover artwork & illustrations
throughout copyright © Sean Madden
Book design & layout: Walt Meaties
(after Magazine of Horror)

Contents

Stephen Sennitt is the author of
Ghastly Terror! The Horrible Story of the Horror Comics
also published by Headpress

ACKNOWLEDGEMENTS

My special thanks to David Kerekes for backing the project. Thanks to John Beal for deciphering the hieroglyphs, again! — I promise you I'll learn to type one of these days.

To Peter Smith, Harry O. Morris, Robert M. Price, David M. Mitchell, A. C. Evans, Norman Jope, and perhaps others sadly forgotten, who first showed interest. And, as always, to Louise, with all my love.

DEDICATION

In memory of 'Archaic' Alan Hewetson, strangely alive yet not forgotten.

Creatures of Clay

THE MURDERER

SEVEN IRON lamps illuminated my path along the river, shining like a black mirror. There was an air of stagnancy, · dripping like tallow. The pallid, fish oil eyes of drowned souls watched me shuffle along hesitantly, peering with fear at the darkness that lay beyond the seventh lamp — but before I got to it, it blinked out and the night got into my startled mouth...

My feet bumped into something hard in the darkness. The orb of the earth turned as I hesitated before stooping to pick it up. It was a bent piece of iron; heavy, lightly rusted — a murder weapon! A dead weight hung upon me as lurid demons obscured the stars. The memories of evil crept up from the iron bar along the length of my arm, and crawled their way into my brain.

Out over the still black river came the chittering of bats.

THE VICTIM

TOO LATE I had found out I was marked for death. The notebook I had been keeping had been noticed by someone in the shadows. I'd seen him occasionally, through my window, unmoving, in the derelict buildings near the river. He'd obviously noticed me writing at night time. He might even have slipped into the room to read my notebook while I

7

slept; his insane mind convinced I was being inspired by spirits of the Dead who wanted me in their company. Well, perhaps I had communed with them in my dreams — but ultimately Fate is decided beyond the veil of Higher Forces than mortal life. It's my understanding that he made his first mistake when he let the idea of murdering me get into his brain. I can see him now, out near the river. His presence hangs on me as if he were here in the room, standing over my notebook. Because he will kill me soon, in his eyes I'm one of the Dead, and always have been. He justifies my death by thinking I *must* be killed at all costs. I have written about all this in my notebook; gone over all the permutations, all the ramifications. But in a strange way, I'm beginning to see he might be right. Or, more accurately, that he might just as well do it as do anything else.

For a while I stopped making my notes. I tried to shut out all the knowledge that was coming to me via the Dead, beyond the Veil of Higher Forces. I was beginning to see a scheme that was so tightly controlled it frightened me. I became convinced that all my movements over the face of the earth — which I'd previously thought were my own choices — were minutely engineered by Fate, absolute and irrevocable: The life of a tenth-generation rat in a maze who doesn't even recog-

nise his environment as a prison.

So, I went out more. Socialised. Got a part-time job. But then I started to sleep again, more and more — long, long hours of sleep from which I couldn't awaken . . . wandering the silent path between Death and Insanity. Sometimes, when I eventually woke up, I would go to the mirror and hardly recognise myself — just a Zombie. Only the feeling of his presence, out there in the derelict wharves, returned to me a sense of identity. I began to open the notebook again. Re-read what I had written, over and over. At first I suspected he might have added a few notes, here and there, when he had come into the room while I slept, but there was no real evidence to support this idea. In a way, I was disappointed. I would have liked some clues as to his agenda which might have been revealed by a comment, pencilled in, here and there. Pencilled in, here and there. But there was nothing . . .

One night I awoke with the terrible feeling that he had been standing over me for long hours, watching me while I slept, brandishing a heavy instrument of death — his white breath condensing on my face, the tool of restless spectres. I got out of bed and stood before the mirror and saw myself alive for the last time. A stray breeze blew through the window. Fingers of the Dead ruf-

fled my hair. The pages of my notebook fluttered, revealing all the pages which would be left blank.

THE VAMPIRE

IN A ROOM above one of the old warehouses at right angles to the sluggish river I made a little home where I felt safe and secure for a while. There was even an old filing cabinet, where I kept the iron bar under a moveable shutter.

The one window was just a grimy slit; the glass in it thick and old, like a stained milk bottle. You couldn't see the sky, only the river. Or rather, the black shape of the river encompassed by gloom as thick as dust. Occasionally shapes flitted about, making my ears ache . . . bats, pendant extremities to the water.

Occasionally, I left the haven of the room and wandered around. There was plenty to occupy me in the miles of gutted buildings and the brown sepia cellars. One evening I found a dead bird. A blackbird which had trapped itself in the confines of a small space, and had panicked, dashing its brains out against a crumbling plaster wall. I remembered a time some years previously when a blackbird had flown into my house on a warm spring day, and how I shrieked in unexpected fear as it pierced the back of my neck with its beak in the extremity of its terror, before falling squarely into a bowl of disinfected water which I'd been using to wash the bedroom ornaments. Soon after, feeling that I was being observed, I turned the painting of a group of blackbirds in the living room to face the wall — to counteract the haunting atmosphere. It didn't work. After a few more days I had to move . . . an extensive curve to the left . . .

I left the dead bird where it was, afraid to touch it. I maundered around for some little time, but the spirit of exploration had been knocked out of me. Back in the cold night air I saw a light out on the river. A lump of fear came into my throat. Behind me, iron gates swayed in the breeze making the noise of a chasm. Along the river an unexpected boat glided, eerily silent. The sky reared up behind it like a mountain. It swept gently in a straight line along the greasy channel, effulgent like a wreath. It glided with the grace of a swan to the wharf.

From my hiding place, I saw a man lift a cumbersome chest out of the hold and hoist it up with a rope from the deck onto the embankment. From there, he pulled it along into the building I had just vacated, and then he was swallowed by his own echoes as he grunted with effort. Slowly the echoes faded. I waited and waited — perhaps he wasn't going to re-

emerge...? But, no, after a time he came scowling out of the blackness, mopping his brow under a thick mass of black hair. He disappeared back into the shape of the boat which glided out onto the body of the river.

Obviously, I was intrigued by the chest and its heavy contents. Despite my trepidation, I lost no time in going back into the black hole to look for it. In fact, I knew it would be in the chamber where I'd seen the dead bird, its round alabaster eyes shooting this knowledge into the summit of my brain.

By the time I had retraced my steps, and found the crypt in question, the thing which had been in the chest had emerged. It stood waiting for me, standing in the hollow of the box, the lid thrown back to reveal a tall, thin figure, painfully emaciated, its lank, black hair parted down the middle and hanging over the pitiful white face like partly drawn curtains. Its long, spindly arms and legs were bound in filthy gauze, and here and there spots of wounds, brown rusty stains, showed through . . . It made no movement. It might have had no eyes, but I knew it was watching me. All at once, it began to make a terrible wailing sound. The air around it seemed to displace, like waves lapping. It clawed at the air with impossibly long, double-jointed fingers, filth encrusted shards of nails — and one of the fingers was missing, reminding me of a spider whose leg has detached apparently without causing it too much discomfort. And then, I saw its teeth — long iron white fangs, strong and unbroken, in complete contrast to its dishevelled appearance. I sank to the ground, tears springing from my eyes as bolts of terror ran the length of my body; from the tips of my toes, to the crown of my head, where bursts of black radiance were lapped greedily into the waves of displaced air...

Finally, as the shrieking reached a higher pitch, the vampire began a sort of writhing dance in which various joints cracked and popped, as though dislocated. I couldn't look anymore. I wrenched my head away and forced my face onto the floor. I heard the thing move towards me. I hardly flinched as it felt for my neck. Now with urgency, its teeth scored and gouged, peeling at my skin like a knife scraping at a potato. When, at last, blood began to trickle from the chaffing, the Vampire began to suck and suck for all it was worth. Flakes of its rancid skin fell into my outstretched hand . . . the dead blackbird couldn't fly, so it scuttled away like a rat.

THE GHOUL

THE WINDOW had been smashed. The one, grimy, nar-

row window . . . thick, semi-opaque glass on the floor. I ran my fingers over a suture in the iron bar: along a trickle of dried blood on my neck. For the first time in ages, I felt as though I must leave the river docks for a while. My sanctuary felt invaded.

Darkness enveloped the wide high street. Stationary cars huddled beneath tall, lightless buildings. A stray live wire sent out desultory sparks along the tarmac like a beached eel. Bushes in the park were in their death throes.

Where was I headed? Through the path in the park towards the lake . . . water drawing me again. Still, black water. A paddleboat meandered near the toy-like jetty. No one was laying down in it staring upwards. I kicked at the loose shingle back out on to the street. Then, down an alley . . . shadows of cats streaking by like traces of beings from a higher dimension . . . I was remembering where I was now! A little further down — a side alley — and another turn . . . a doorway; the overhead hoarding obscured in darkness but vaguely squeaking in the night air . . .

I tried the door, a little surprised to find it open. The dim, blue lights revealed an empty corridor, a chair, a small table with a roll of blue paper tickets and a cash box. The walls and roof of the passage were carpeted with the same deep blue shag-pile as the floor. No one would hear me . . . I padded up to the table, lifted the cash box and rattled it loudly . . . I banged it smartly against the table (no, no — it didn't give way . . . it didn't cave in like a skull under the weight of a curved iron . . .) I'd never seen stars before my eyes before — but there they were! The next thing I knew, the little man was taking me by the arm and sitting me down. I couldn't tell what he was saying, but there was a note of oily, practiced concern in his voice — he didn't want to miss out on some custom in this fucking tomb . . . He handed me a drink and a ticket. The wooziness passed. The dwarf lit me down the corridor and showed me to a seat in the empty theatre.

Ten minutes passed. Then the film started: 'Dragon Girls.' I looked around as the titles flashed light into the void. The cinema *was* empty. I finished my drink . . .

The film started: A young girl was heaving under the weight of a Komodo dragon. Its thick rasping tongue flicked her white face and covered it with instant wounds, as though her face had been scraped with sandpaper. The camera shifted to reveal a ludicrous shot from the back, as an actor with a lumpy costume on, his back painted green, fucked her.

The scene changed: Three men in cowls tied a girl (the same

girl?) to a stake on the floor of a pit. They took turns to fuck her. Then they took a knife and made little incisions all over her body before pouring a bucket of sticky, yellow substance on her. One of the men released a catch on a broad wooden gate, before all three of them scampered with haste up a rope-ladder. Now they looked down onto the girls' frenzied, screaming face as a posse of loathsome reptilian shapes crawled their way towards her. One of the men ejaculated into the pit — and suddenly there was an impossible bright explosion of light on the screen which momentarily blinded me . . . In the ensuing silence, I heard someone move towards me, bumping around in the dark. When the dim house-lights came back on, the movement stopped abruptly. I scanned around in confusion, keeping low in my seat, but it was a long time before I noticed a few stray hairs poking up from one of the seats in the front row. I slid from my seat and crawled on my hands and knees towards the now blank screen. Peering cautiously, I could see that the figure in the front seat was slumped lifelessly, legs stretched out, one of the shoes kicked off. It was a woman. I got up from my crawling posture and walked towards her. I sat next to her in the front row.

I didn't think about whether she was attractive, or not. There was a trickle of blood running from behind her ear into her short hairline and down her neck. The terrible face — such as it was — of the vampire flashed into my mind for a second, and before I could stop myself I'd placed the tip of my tongue into the thin stream of her congealing blood. In next to no time, I found myself tearing ravenously at her throat — at her bare upper arm, speeding dizzily round — a broad belt of red gleaming spray — my existence defined in her circle of spraying, sweltering flesh movements — I slipped into the red mouth of a terrific funnel — swallowing chunks and strips of pink meat — smooth whirlpools of fat — the black water of her warm organs . . .

Half-devoured, she rested lightly in the crook of my neck and shoulder while I masticated in foams of salt — in a monstrous velocity. The horizon of the bare screen was tilted at an angle, speeding dizzily around. I saw jet-black stars before my eyes. Suddenly there was an appalling voice, half-shriek, half-roar; a cataract of agony. I thought she'd come back to life! — a shredded freak of skin and bone . . . a fly sucked dry by a devouring spider . . . but it was me: I was screaming and retching as I wound myself back in on a thin, fragile thread leading downwards.

THE ZOMBIE

I FOUND myself standing in front of a shape which might have been a mirror. There was a waver of vague movement in my immediate view which I took to be some kind of reflection; but after all, it might just have been a myopic rippling of the horizon — something like a heat-haze. I can honestly say I didn't know where I was. It wasn't a problem of the eye. In a way I can't possibly convey, my sight was functioning normally. And yet, I couldn't really see anything. I felt around the room as though I was in pitch darkness. I walked from one wall to another, feeling for cabinet drawers, mirror surfaces, picture frames . . . but all these things proved to be elusive. I tried to think about a solid, heavy object I might have lost, but thoughts puffed out as quickly as they came.

Vaguely panicked, at one point I realised I had no memories; but what had surged up as tangibly as vomit one second, became just as quickly suppressed the next! I had the fleeting feeling that I was like some sort of doll, kept in a box, with no real life of my own other than the few, stray thoughts which were donated to me by my distracted keeper — like a child who momentarily determines the characteristics of his toy, only to bore just as quickly of the game and scrap his vague

definitions in favour of something equally nebulous . . . A creature which might in one split second become something outrageous, like a missile, only to rot in utter disuse in the following long years . . . faded and forgotten.

Perhaps I wasn't even pacing the room — perhaps I only thought I was pacing the room. In reality, I might have been laying in a comatose heap, feeling around my own darkened mind like something blind in a vault. But there was a sense of pacing. And then of standing . . . standing before an indiscernible shape of greyness . . . a slight ripple of movement that I thought, somehow, might be a reflection; so that I daren't walk towards it.

THE SLAVE

BOOM! . . . Fingers of the dead ruffled my hair . . . pages of a notebook, blowing in the breeze through an open window . . . I awoke with a start; stomach cramps and nausea — my face was a white unhealthy blur. I began to pace slowly around the room, gathering my recollections together of the dreams I might have had. And then the booming noise sounded again, followed by an almighty crash. So, this is what must have awakened me...

Outside, against the dull sky, a crane with a wrecking ball was knocking down columns of bricks — remnants of a warehouse or a

forge; fingers of grotesque Grecian pillars, grasping dust rising into the air.

Something was missing, however. No shouts, no voices. Just the cat-whir of the steel chains and the doom-like collision of the wrecking ball on to the bland, dusty rows of bricks. No workmen around to clear up the stinking rubble. Spiders, rats and sparrows were making hasty exits out of the chaos.

I watched the figure in the crane all day, and when he left as the sun went down I ran over to the empty crane to examine his handiwork. He'd certainly done a good, methodical job — only mounds of rubble and low, stubby walls remained. Some of the now vast-seeming area had been crushed flat, so that it was quite easy to walk in the gathering gloom without fear of falling. But I did fall.

I awoke in a dark earthen tunnel, miraculously unhurt. The moon shone through the gap above my head showing a jagged hole in the brick floor where I had fallen through. Even now, loose earth and brick fragments were settling down the hole, sliding down on me, occasionally dropping like dead moths from a ceiling.

I shook myself and tried to find a way to get back to the surface — but there were no handholds. As soon as I attempted to grip something, it shifted abruptly and

fell into my spluttering face. There was nothing else to do other than head down into the dark tunnel.

I was relieved to find that the total blackness didn't last for long: after a few minutes the tunnel ended at a stone-built cellar which had a barred air-grate at the far side, letting in some moonlight. I dropped into it easily, sliding down with a mound of black earth onto the solid floor — but once inside I found I couldn't reach the air-grate; and a quick glance around soon proved that the cellar was completely empty. I tried to think . . . fingers of a breeze behind me ruffled my hair . . . I spun . . . a door was opening . . . I pressed myself into the dark shadow cast by the open door, against the wall, trying not to breathe . . . a flash of white, like a skull, and the door gently shut to again . . . then, there was a muffled scream of agony. I padded over to the door, my heart leaping in my throat when I heard another muffled gasp of agony and terror from the chamber beyond. I felt a dead presence float over the space between my mind and my heart, haunting the soul's dead lands — the endless reflecting mirrors at the ends of a corridor between insanity and death — jet black stars before my eyes — the door tilted at an angle before I had even realised my hand had pulled it open. There was the dead-man who had

worked the crane, his drab white skull a testament to the sick monotony of torture and pain . . . the boredom of horror. In his left hand he held a chisel and in his right a hammer, and he was chipping monotonously away at his victim's shin-bones, bloody shards flying into the dull grey air, whilst the slave on the butcher's block, manacled like a beast of burden, strained at his mouth gag, his face awash with blood where he had been scalped, surrounded by an oozing mass of his own skin and blood, body fluids and shattered fragments of bone scattered on the floor. The torturer turned to me with his skull-face and handed me a pair of heavy gauntlets and pointed to a space in the crumbling wall where a huge spider was huddled, like a hairy football, its legs folded in. Sick with revulsion, I grasped hold of the thing before it could clamber away, carrying it at arm's length to the slave and placing it on his exposed genitals, as I knew I must. The dead-man looked at me from his black eyeless sockets and began to smash the slaves' fingers into a pulp with the hammer. Tears were streaming down my face as he choked on his screams behind the gag (. . . who would hear him down here in this vault anyway?) Sadly, dully, I partook of some of his flesh and blood. The dead-man took an axe and lopped off his hands and feet, each time with

only one swift, mighty stroke. The spider, mottled green and brown, sprinkled with dust like grey ashes, tore intricate wounds in his abdomen as he passed out. I slumped with relief, feeling soon that this poor slave would die — but no! The dead-man heated up an iron and quickly staunched the flow of blood from his terrible wounds. Then, he motioned me to lift the spider and replace it in its crumbling niche . . . with skeletal fingers he raised a small syringe, and injected the slave squarely in the heart, slamming the needle in with a snap of gnashing teeth. The slave's bowels vented a terrible liquid eruption as he awoke with a violent scream . . . eyes staring in madness. Methodically, the dead-man began to saw pieces of flesh from the slave's left arm.

THE WANDERER

AFTER A SHORT time, I began to feel myself floating up from the table — slowly at first, and then in a sudden rush as my spirit seemed to gust like a violent wind through layers of cobwebby mortar. There was a brief, giddy sensation of pleasure at this release from agony, and then I entered a depressing grey fog, flecked here and there with almost slimy patches of sulphurous yellow. Though apparently not corporeal, I gasped for breath and clutched at my throat, kick-

ing madly in the dense atmosphere until I began to lose consciousness. When I came to, I was in a flat, toneless grey landscape — a smooth, clayey expanse from horizon to horizon, with no relief to break the eye . . . As I rose up, taking my weight with out splayed palms, I felt the surface of clay give a little, releasing a trickle of moisture to its surface . . . Blankly, I began to trudge forward into the half-light . . . with thousands of others just like me: Creatures of Clay.

Part of the Sequence

I SAW THE advertisement as I passed him, seeming to gather up the dust which settled back onto the hot earth when a car eventually passed. He tipped his hat to me, so I ventured to ask if I might borrow his paper for a few seconds.

He smacked the dust off it, and handed it to me. Where his hand began and the paper stopped I could not say; both were like incredibly old and dusty rock or hollows in old trees unlit by sunlight. He smiled — I'd seen him before — he said:

"Are you staying at the old lodge?"

"I am indeed," I said, scanning to find the page with the advertisement on.

"Good, good" he said nodding emphatically. "I know Mrs. Lanchester who lives there, she is a fine woman, well respected."

"Really?" I said; I couldn't find the advertisement at all. Overhead a helicopter passed westward, casting uneven shadows like a mechanical cloud.

"I must mention that I've seen you to Mrs. Lanchester . . . what's your name?"

He smiled, pushing a piece of hair back under his dusty hat, "Ah, she knows me. Say you've seen the old man — she knows me alright."

"Ok, 'the old man'" I said. I handed the newspaper back to him.

I STARED back to where the footpath stopped abruptly, and a

breeze blew the tall grasses into my face. I pushed them away, staring at my last visible footprint. Above this was a wooden stake which had been driven into the ground, crowned by a sun-baked mummified head that was almost a skull.

I was far into the undergrowth when I began to smell a sweet smell, as though there were a large expanse of water nearby. I could smell the freshness of it and the tops of the grass beat in a cool breeze which I could touch reaching above my head. The voice of water was on the wind. Illogically, I became happy, beginning to run through the grassy semidarkness until at last I came to a clearing. The blinding semi-circle of sunlight was breathtaking. I let my eyes adjust to its strength grinning at my own stupidity. Slowly I opened my eyes. The breeze was gone. There was no water.

WE WERE in the attic of the house sitting on Mrs. Lanchester's bamboo furniture when I said suddenly:

"I saw a man today. I saw him and he said you'd know who I meant if I said he was called the old man."

Mrs. Lanchester stared quite astonished, looking up from her study of the cold tea in her icy glass.

"Who? No. Never heard of him."

"Really? He said he knew you. He intimated that you'd known each other for a long time."

"Did he indeed? What does this person look like?"

Paper, I thought, dry cracked old paper-mâché cracking in lines from the planets, cracking apart on the moons of Saturn.

"Old!" I smiled; "Worn. A brown dusty suit and hat. Brown dusty skin. A rather old sounding voice, a bit high-pitched I suppose."

"Sounds charming," laughed Mrs. Lanchester.

"Have you got today's paper?" I asked.

"Yes. It's there next to you."

I looked down and saw it there, resting over the creaking crisscrosses of bamboo. I saw the advertisement too, bold, large. How could I have missed it?

"I want to know more about this old bogey-man who seems to know me." Said Mrs. Lanchester.

I looked up, trying to find something to say.

"Well, there's not much else I can tell you. He was fairly cryptic, one of these 'a nod's as good as a wink' characters."

"Where was it that you saw him?"

I thought for a moment...

"At the crossroads down in the valley," I said.

AT DINNER Mr. and Mrs. Lanchester and their children, well that's what she called them

— they were both about twenty; a girl Sally and a boy Robert — were arguing about various things . . . Usage of cars being the main theme I believe. At some point all at once they all stopped suddenly, becoming aware of me.

"Oh dear me," said Mr. Lanchester, "We seem to be getting carried away. Poor old Stephen will think we do nothing but argue."

I smiled, embarrassed,

"Not at all," I said, "no, no — everyone argues sometimes."

Silence. I could hear the crickets outside suddenly in rhythm to our masticating jaws.

"Well, what did you do today?" Said Mr. Lanchester.

"I went for a walk again." I said rather apologetically.

Sally said, "Dear me. You seem to do a lot of walking, Stephen."

"Yes, I like this area. It's peaceful."

They were waiting for me to carry on.

"And," I said swallowing hard, "and I may have found some work. They're wanting men over at the other side of the valley to erect crosses — huge crosses for Easter. It should be interesting work."

"Are you sure you're ready?" Said Mrs. Lanchester, "are you . . . well, do you feel fit enough for that sort of work so soon?"

"I don't know," I said, "I think so."

WE WERE SAT in the attic again.

"It is going to rain at last," he said.

"Yes it is," I whispered, joining him at the window where it had already begun to patter tiredly.

"Well, I'm off to bed. Goodnight Steve."

"Goodnight Mr. Lanchester." He left the room trailing a scent of foliage behind him. It seemed to mingle with the sound of the rain.

"He's off to bed early," I said at last.

"He always goes early when the rains start. He likes listening to it, quiet, on his own. Besides, he's got to be up early tomorrow. He's flying on business to New York."

I sat staring at the advert again. I was filled with a sense of great purpose when I studied it. I wanted to be there at that moment, using my weak limbs to lift, using my hands and wrists to pound the hard wood into place and dig into the earth. I wanted my body to become hard and useful. In the distance of these thoughts I heard Mrs. Lanchester rest down her book.

"You're serious about this job, aren't you?" She said.

"Oh God yes. I'm sick of crummy little office jobs and all that. I want to feel that I'm working. If I spent another day inside that damn place that nearly sent

me insane I'd, well, I'd go insane altogether! I don't know what I'd do."

"But you're not strong Stephen." She said.

"No. But I want to be. This job won't be too heavy for me. It'll train me — I'll develop strength gradually through this sort of work. We'll see what happens from there."

"Well, you're determined and I can't blame you. I hate being cooped-up here. It drives me crazy. But, don't get your hopes up — by the sound of that rain the valley might be flooded in the morning."

"Yes", I said. It hadn't occurred to me. In a way it gave me an excuse to stay on for a few more days. It was odd. I wanted to stay but I wanted to go.

THAT NIGHT I had a strange dream. There was a white girl, naked, big boned with dark half-moon eyes and hair like bleached white hay running through the undergrowth as though being chased. Her feet were marked with strange lines drawn in a colour only slightly darker than her pale maggot-coloured body. I traced the lines up her legs where they met in small geometrical shapes on her inner thighs where they were criss-crossed over and over, melting into a design immediately above her vagina. She ran through the undergrowth looking back all the time, jumping heavily yet lithely over twisted tree roots and impossible coloured leaves.

With a fractured lunge she broke through into a sunlit clearing. And then there was a panther, hungry and dusty black pointing to the water saying,

"There! There!"

The river was a torrent of noise, bells and bones rattling over shredded green English bed of mossy rocks in a continuous exaltation of small vortices and whirlpools. At once the white grubby girl plunged in, feeling the startling sharp coldness and hearing the high pitched riverbells of sound in a furious rushing cascade. It was almost close to dying. She gripped at the icy surface and began to swim, trailing a scum of soily dirt behind her which washed away. She came to a partly submerged tree. Swimming below its brittle branches was a spotted jaguar or a leopard. It was a fierce, huge animal, eyes sparkling in a head which always surfaced the river. She put her arms around its pulsing neck. It began to swim, taking her forward with it. Soon, she found herself on an outcrop of rock, warmed by the sun, staring out over the river of which she could see no end.

THE SUNLIGHT was warm on my face. I pulled the bamboo shutters back fully, shocked to find that the garden was flooded.

The steps which led to the second incline of fields were partly submerged.

I drank a glass of orange-juice and smiled briefly at Sally, who sat at the kitchen table looking odd. It was always odd to see people so sun-tanned looking so unhealthily tired as every one does early in the morning. One tends to associate suntan with liveliness and nothing else — tiredness looks so out of place on a pretty, sun-tanned face.

All at once I asked her,

"Sally, have you heard of a man who just calls himself the old man?"

"I don't think so," she said, "why?"

THE SMALL OUTCROPS of rock looked pitifully sparse as I gazed out over the drowned garden. I heard a noise from behind me — a small bird had fluttered down coloured like a huge butterfly with glazed perfect eyes seeing a world destroyed. It flew away quickly making no dust rise in the air. No dust at all, everything was congealed in mud.

"You'll have to wade neck high all the way to the hill," said Mrs. Lanchester.

"Good morning." I said, "Yes I suppose so. I suppose I'd better not risk it. Pity, the closing date's the 17th — that's Wednesday."

Mrs. Lanchester looked into the clouds smelling the water on everything.

"It'll have gone by then. The going will be heavy but you should be able to make it over there on Tuesday."

"You've accepted the idea then?" I asked.

She turned towards me.

"I'm not here to order you about Stephen," she said quietly, "I'm sure you know what's best. Only you can know how you feel."

I felt awkward. I smiled at her dryly, looking away licking my white lips.

"You don't think it'll rain again then?" I said.

Mrs. Lanchester said: "No. Not this week — I can tell by the sky. The horizon."

She went indoors and I heard the chair creak softly as she sat.

The garden looked impossible. I imagined all the submerged flora as though they were beneath a deep green ocean. Orange fiery blooms turned a trampled hateful corpse green, already developing leafy gills, trying desperately to free themselves from the sea bed and swim away in a trail of pale green poison.

THE DAYS PASSED quietly like a clock that cannot tick. It did not rain. In my bedroom I studied the advertisement for hours. Sometimes a feeling of great intensity gripped me and afterwards I felt strange that I should be so affected. The crude black and white drawings of the

crosses croaked like birds of stone. In my imagination I saw myself erecting them to plan — a great white flapping plan-sheet or blueprint marked out nearly luminous against my stripped bronze skin. And then with my arm around the strange white girl I would look out over them against the horizon to the sound of the crickets. With eyes of blue steel.

AND I CONTINUED to dream. Always the same constant river, so madly alive yet a poltergeist of a river, thrashing snake-like tambourine noises twisted along its course, eroding the silence of the undergrowth. Then there was the girl. She was *so* white — yet not an albino, her sharp eyes were coal-black like the great cats who marked her endless journey along the river. In my sleep I knew her name, I knew the river's name, the fierce leopards called it from their pounding hearts, their savage aching jaws. In my sleep I always knew the names but when I awoke only the images remained.

One night I was awakened by Robert; his eyes were wide open and alarmed. Sweat stung my eyes. My temples thumped. His strange voice droned out a sentence I could not hear. He shook me, recoiling from my sticky wet hands but unable to move, finally I heard him say:

"Let go for God's sake! You're breaking my wrist."

"What happened?" I said.

"You were shouting like a madman. You were screaming . . . well sort of."

He looked pale and small before me in the electric light. He gripped his wrist.

"I'm sorry," I said, "it must have been a nightmare."

"You're telling me!" said Robert.

"What was I shouting?"

He looked puzzled and doubtful. At last he said: "I'm not sure Stephen. It sounded like . . . well, I don't know."

"Can't you remember?" I said.

He shrugged.

"It sounded like you were shouting 'sister'."

"Sister?"

"That's what it sounded like to me."

At that point Sally and Mrs. Lanchester came in.

"Are you alright Stephen?" Said Mrs. Lanchester.

"Yes. Robert woke me up — I must have been having a bad dream."

Sally said, "Stephen, look — your mouth is bleeding."

ON TUESDAY it was humid. The rain had kept off, but most of the land was a mess of mud and ruined plant life. I awoke early, bathed in sweat as always, my stomach pounding at the thought of the day's journey. I let myself calm down before I

dressed.

Entering the kitchen, I saw Mrs. Lanchester opening the fridge door.

"Good morning Stephen." She said.

The kitchen seemed oddly disarrayed in a way I could not say how. As Mrs. Lanchester stood slowly I saw that her left cheekbone, beneath the eye, was a dull bruised blue colour. She gave me a tired smile.

"Let's have breakfast in the attic," she said, "it's much cooler up there."

"How did that happen?" I asked. She changed position on the creaking bamboo chair and began to pour out a glass of orange juice which she handed to me.

"I won't say that I slipped or anything," she said, "No. That would be silly and obvious to me. Bill did it. He's gone."

"Mr. Lanchester?" I was outraged by learning the truth, even though I had guessed.

"I thought he'd gone away . . . on business."

She stirred her finger around in the orange without looking up.

"He came back late last night. We argued and now he's gone."

"Just like that?"

She raised her head to look at me, "Oh, Stephen, it's been going on for years, it really has. A long time before you came we split up for a few months. I'm just sorry there should have been all

this domestic squabbling when you were here."

"What are you going to do?" I said.

She said quietly: "I don't know."

After a while she got up and stared out of the window over the valley below.

"It will rain again tonight," she said.

I said, "I hope not, I wanted it to keep off until I've found some digs or what ever you call it over there."

"That should be no problem, you'll probably live in at the camp if you get the job."

"And yes, I never thought — if I don't I may have to travel back tonight in God knows what sort of weather!"

She looked at me very strangely then — for the first time very suddenly I found her unattractive. I cannot say why.

"I suppose it's a risk I'll have to take," I said, "because I can't put this off any longer."

She continued to look out of the window that was being constantly tapped on by flying morning insects. As I ate I beat out a tune in my head to their hot mournful rhythm.

IT WAS NINE-THIRTY when I climbed in the car beside Sally. I rolled down the window.

"I'll be back to see you sooner or later Mrs. Lanchester," I said, "but I'll say thanks for having

me now. You've no idea how much I appreciate what you've done for me."

She smiled briefly, not saying anything, looking aloof. As we drove away I turned back to see her clearing some mud off the path with her feet.

"How far would you like me to take you?" said Sally.

"Oh I don't know. Which way do you go after the junction?"

"To the right, toward the city."

"Well, you can drop me off there at the crossroads then if you don't mind, I have to go the other way."

"I don't mind," she said.

As we drove along it seemed unusual that hot dust did not fly in all directions. I was not used to the rainy season, how it altered everything to seem amphibian-like. The long hot snake of the road had become a water snake, at home in either worlds of dry dust land or beneath the rivers of the flood.

I thought of all this as we drove along oblivious that Sally wanted to speak. She was obviously uncomfortable in the silence. Even so, in ten minutes time we came to where the roads crossed.

"Well Sally," I said, "thanks very much. I mean that in all ways. Your family has helped me a lot during the past however long it's been…"

"Don't worry about that," she interrupted.

There was silence. I sat there unsure what to do or say. Eventually I opened the car door and got out onto the hot wet road.

"Thanks again." I said. She smiled at me briefly before turning on the car radio. I shut the door and she drove away towards the west and the waiting city.

OVER THE ROAD he was there — the old man. Somehow I expected him to be there. He looked at me and smiled inanimately, brushing the side of his face with a newspaper.

"Hello," I said.

He handed me the newspaper. "Seen this?" He said.

There was the advert, strong and bold as ever, still sending a surge of something through my whole body.

"They'll have to move quick to get them up before the rains come good and proper," he said.

I handed the paper to him, quietly saying, "I've seen this before. I'm on my way over there now hoping they'll take me on."

"Oh they'll take you on," the old man said, "they'll need every man they can get."

I said goodbye to him turning my way towards the path in the undergrowth. I looked back, seeing him wave. He shouted, "Good luck boy. I'm off to pay a visit to Mrs. Lanchester now."

Before I could say anything he had gone.

The undergrowth was a mass of buzzing insects of all shapes and colours, crawling and flying on the overbearing dripping humidity. I made my way along, watching the slow steaming current of them circle in and out of the tall wet grass and over hangings from trees like over-ripe dizzy fruit careering down into the sub-aquatic rot. Everything in the undergrowth was finely intertwined. Small wet branches gasped upwards for air so that they almost heaved their way towards a free patch of sky. The going was very hard. Sooner and sooner I found myself having to rest, but I could not relax in the cloying heat and assault of the insects. It must have taken me an hour to come at last into a clearing.

I was surprised to find myself on top a slight incline looking down to where I could see my path trampled-down in the distance. All the time I must have been climbing slowly up hill but I had been unaware of the fact. Now there in the distance, I could see that they had erected the first cross on a newly cleared hillside. I began to walk towards it, keeping it in sight always.

IT WAS MID-DAY when I reached the site, fatigued, breathing heavily, in need of water which I had stupidly forgotten to bring with me. Fortunately the foreman saw my plight and suggested I wash and relax whilst he arranged an interview for me with the construction leader. I had explained to him that it was physical work I was looking for and asked whether this being the case should he not judge himself, as he was in charge of labour.

He said briefly — sarcastically — "Sir; you are white. That being the case it would be unwise for me to judge your case."

I said; "I didn't realise that it mattered all that much."

I sat around for a time watching the frantic hustling of strong bodies heaving ropes and digging holes, unloading the huge trucks that mounted the hill, nailing the two pieces of the crude crosses into shape for planting. It was hard, fast work. In the short time I sat they had erected twenty-five crosses. All the time a sequence of well-planned actions continued furiously. The whole wrecked hillside was a buzz of giant engines and loud voices, the total menagerie of sound made the sky creak and heave unable to cope with its strangeness so far was it away from the city.

At last the foreman approached me.

"The Boss will see you now." He said.

I entered into a large tent. All around were maps and sheets of paper showing complex diagrams. Amongst the scattered debris of paper was a tall sun-tanned man

with sandy coloured hair.

"I'll get you a chair," he said.

He cleared some of the rubbish out of the way and unfolded a chair, resting it rather totteringly on the dusty floor.

"Thank you," I said.

He sat down and now his eyes were fixed on mine.

"So you want to labour here today?" He said.

I said: "Yes sir, I do."

He frowned looking me up and down. I just stared into his face, feeling the sweat begin to trickle down my temples.

"You realise it's useless." He said.

"What do you mean Mr. . . . er?"

"Oh . . . Mr. Lyle. And you?"

"Er, Jakes. Stephen Jakes."

We shook hands briefly. Lyle looked uncomfortable now that names had been mentioned. I said again –

"How do you mean, useless?"

"Well, we'll be finished by sunset and that will be that. And I think that its useless anyway, because the rains will set in for good tonight and by morning everything we've done will be washed away."

"Why do it then?" I said.

He looked at me with a sadness I could not interpret.

"Orders." He said.

"I would still like to work." I said.

Simply he said, "No."

I must have looked startled. I wanted an explanation.

"Everything has gone to plan so far," said Lyle, "as you've probably seen we're working to a very strict procedure where each man is like a cog in a machine. Every man is in sequence. That's why the work is being done so quickly. I've planned it for weeks. I'm afraid Mr. Jakes, that even one additional man could break the sequence and that would slow down the work."

"Yes. I understand. But if you knew all this why did you advertise for extra helpers in the papers?"

Mr. Lyle looked at me, cocking his head awkwardly. At last he said:

"I didn't."

I WATCHED them all afternoon in the intolerable heat. They worked until I could smell the brine sweat in the air, heaving and grunting and gritting their teeth so that eventually, that too seemed a part of the sequence.

There I sat. I felt pale and useless, without life. I could have sobbed easily then, but something held back. I sat still, scorching, content that I was perhaps also part of the sequence, just by being there.

By and by, I thought of Mrs. Lanchester. I wondered what she would do now that Mr. Lanchester had left. I thought of Sally and Robert and the dreams of water. Beneath the shadow of

the crosses.

They had finished by five o'clock. The sky was deep and threatening. One by one the little makeshift tents were taken down and packed away into the lorries to be driven back to the city. When everything was done Mr. Lyle came over to me, wincing beneath the sun's assault.

"I can hear the thunder now," he said, "still, it's all gone to plan and there's nothing you can do about the weather is there Mr. Jakes?"

I was surprised, he shook my hand.

"You look sad," he said.

"So do you" I said quietly.

"Not really. No. Not at all."

He walked away giving a signal for the convoy to start westward.

I WAS BACK in the undergrowth when the rain started. At first it was a slight patter like English summer rain. In just a moment it became a torrent forcing me to the ground. The sky rumbled and coursed overhead ready to drown the world, gushing forth like a prehistoric whale — a huge dead fossil splitting apart in coughs of savage thunder. I lay there still. I could not move. The rain was a force on my back such as I had never experienced. I was afraid. I was truly afraid that I might drown so torrential was the downpour. The sky crashed like dirty brown

whalebones ripping asunder the carcass on the beach emitting all its foulness into the blue sea. A sea that came back in vengeful tidal waves washing away the ruined land.

Soon I began to choke, realising that the rain had begun to flow down towards me along the path I had cut through the undergrowth. I spluttered, trying to raise my body from the mud — out of the river I had made. The sky leviathan thrashed heavily — thunder and lightning continuous, blowing back the trees and plants into the past when everything was beneath huge oceans.

At last I managed to stand. I rang out my draggled skull forcing my face upwards to see the flooded path ahead. I thought:

"I will drown out here. I'm going to die out here."

I could not walk. The terrible rain forced my head down, closed my eyes up. I was afraid to open my eyes for if the rain clawed them out, washing them into the submerged earth. Slowly I was forced to my knees. The water trickled through me. I was no longer there. I lie down to let the river flow through me, washing through my blood, bleaching my sticky bones to form as rocks. I lie there tiredly as a part of the flood. I thought — dramatically:

"I shall. I shall be Eternal."

Just then, something jumped over me, landing far ahead splashing away down into the

valley. Through the pouring rain I could just make out a figure which had stopped, flinging a wet pure-white arm across its brow looking back at me. This was for an instant. In that instant the rain seemed to stop. I saw the figure; a pure white skinned girl swing her straw coloured hair away from me heading towards the valley. I meant to shout: stop! I meant to scream: who are you?

I said over and over again: Sister. Sister. SISTER!

In agony I pulled myself upward, my spine bending into a half-moon under the weight of the water. I tore myself forward from that part of the flood which had become me and screamed forward running faster than I had ever ran. I could not see and I could not hear. But the cry tore out of my body. The cry tore out my intestines like a wild beast, tore out and up my malforming spine splintering the air through tortured teeth. Many times I nearly impaled myself on the branches which were alive in the watery air, in the wild wind which tore holes in them falling branches in my way.

Still I ran alive and submerged, blood coursing from my eyes, my ears, my nose, my mouth, tearing apart. I gasped for air but the sky was full of water. I gasped for air until I thought that I would burst open my chest, my ribs in a tide of broken blood and bone.

I ran on. I ran on.

With a crash of lightning I exploded out into the clearing rolling over and over swallowing mud and rain, impaling my self on little rocks and sticks. At last I sat up, pulling the splinters from my hands and face. Suddenly I felt a hot savage breath at my back. I turned seeing a huge black panther with pale eyes. Strange pallid pale eyes pointing towards the river —

"There! There!"

And there it was, ringing cool and clear like a cold ghost's twisting fingers. I ran towards it and plunged into the sparkling depths feeling the coldness surround me, washing away the blood and fatigue from my body.

All was silent save for the river's gushing. The rain had stopped.

All around me swam savage cats. Strong and lean with bodies of fire. They swam with me until I found a rock large enough to rest upon.

IN THE QUIET attic I sat across from Mrs. Lanchester. The lower regions of the house were flooded.

"Where will you go?" I said, "Are you staying here?"

"No, no." She said," I think not. We've a place in the city that Bill doesn't want. We'll all go there."

I nodded. Below I could hear Mr. Sanderson and his sons

clearing things up. They had been boarding up the windows and doors. Mr. Sanderson came into the attic.

"I think we've all finished," he said.

He was a huge muscled man with a large black beard and piercing black eyes. His two sons were only slightly of a lesser physique. They stood behind him eyeing me amusedly in his shadow.

"Would you like a drink?" Said Mrs. Lanchester.

She got them some beer out of a lined bag on the floor. They sat for five minutes drinking it down, having little to say. Eventually, they left.

After some time I said,

"They don't like me."

They were there the evening before when I emerged out of the flooded garden. I banged on the window where I could see Sally talking to one of the sons. They were knee deep in water. Just before I fell they saw me, rushing out pulling me from the water. I had fainted. As I was lifted semi-consciously upstairs I heard someone say that the rain had started again.

"I'm sure they don't like me." I said.

"Why?" said Mrs. Lanchester.

"They resent me being here."

"Nonsense."

"No, they do. They think I'm weak."

Mrs. Lanchester said very quietly, with no malice at all,

"You are."

I WAS AT the door, knee deep in water looking at the newly formed river that had led me to the submerged garden.

"Are you going for good then?" asked Mrs. Lanchester.

"Yes," I said.

"Do you want me to take you to the city?"

I shook my head. "No," I said, "No. I would rather walk. I reckon I can pick my way over these rocks over there towards the higher ground."

I stood for a while on such a rock near the house. I saw Mrs. Lanchester start up the red motorboat. She drove it down the submerged driveway sounding the horn. I seemed a long way above where I stood waving until she was out of sight.

I remembered her saying:

"It's a pity you've been here amongst all this domestic squabbling."

I smiled. The sunlight was soft and warm on my face as I trod carefully from hill to rock, rock to hill.

From a distance it must have looked as though I was walking on the water. I grinned feeling abstractly happy as I came towards the stone steps where I could see a man with two little boys beginning to climb.

I stood above the cool green water crossing from point to point, using no line.

The Prisoner's Tale

I KNEW nothing other than I was to be taken to a place of detention. I had no idea what form my punishment would take. Columns of smoke drifted up to mingle with the low grey sky as the ship docked; the lord of all frosts half-veiled the lifeless world. Something more solid defined the grey landscape, shrunken in the grip of a white hand, clenching in brown mud, the white veins of distant battlements along the arm of a reanimated corpse in threads of ice that cancelled the light. In this place I knew immediately I would regain my fear of God and the devil.

With hands tied behind my back across the level of a frozen marsh, I was marched by silent figures towards the white promontory of limitless ice. Fingers of stone and battlements like candle-wax stood out like the temples of a hanged man as the miserable prison tower came into dim sight, a ghastly fallen angel with the ruined mouth of a congenital idiot. I side glanced at one of the hooded guardians, his piggish face etched with fear without empathy, selfish and empty as the grey lifeless bushes grew sparser but taller, as the incline steepened. His eyes darted in the pallid gloom as a long sucking and loud explosion sent vibrations through the sick air, as a segment of land fell away some-

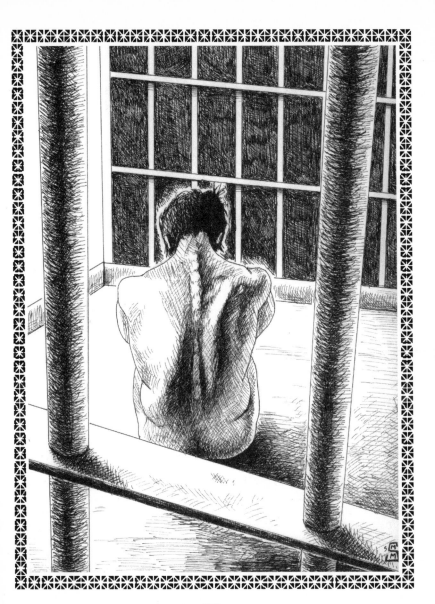

31

where to our right into a broad frozen river. From this wound, a quickly perishing cloud of mosquitoes, released from some tepid pocket, descended on the line of figures which made our group. Unhooded and hand-tied I suffered a few desultory bites before the severe cold made empty husks of the colony of pests.

Needlessly, I was roughly exhorted to 'keep moving'; the pig slit eyes peered beneath the hood, through the rancid breath-cloud caused by his exclamation as the guardian looked at me, and then beyond the dimension in which I existed.

Life is a short, terminal disease, incurable by death, I thought. What is not understood is that the fundamental symptoms of existence are not interdependent in any way, but completely separate, totally opposite. Anyone who says that life springs from death has not seen the gas-bloated, rotten remains of a month-dead corpse, or understood its disgusting litany to the Lord of the Flies. Humans can only imagine death as another sort of life. In reality they are mistaken. Nothing could be further from the truth. Death is nothing at all. Its emissary on earth which we call Death is Fear. Fear is the tunnel which leads to death, so that when one fears one sees death all around in the world; the whole teeming planet becomes a grinning image of death in endless black space, taking on a phantom life within the tortured human brain. Thus Death triumphs over life, as much by what it really isn't, as by what it really is.

And all along the route to the tower, these savage hills wore the mask of death. Ice cracks in the furrows of frozen valley marshes, the iron twilight sky acrawl with hoar frost, frozen mud snuffing the wind. When at last we reach the battlements and the prison gate rumbled open, and I tried to swallow the bile which had risen into my mouth, (somehow managing to note with mild intellectual surprise how shaken I must be that this should have occurred) I was ushered down filthy corridors of stone into the endless dead time of the universe.

A dead man, white face deteriorated, yet immensely calm, enveloped in preternatural light, an expression somehow beatific with superhuman intensity, was staked to the ground of the cell. What I could see of the emaciated body was so rotten with decay as to appear calcified, showing marked contrast to the white, calmly desperate face which formed a startling transition, like the pureness of snow at the apex of a foul black mountain. And then the dim glow disappeared from the barred archway which illuminated this scene, and I was plunged once more into total darkness. In this grave, all of

consciousness soon diminished to the centre of a web of delirious horror, a cold nucleus within a soul which at length I came to regard as a hollow gulf in place of my heart. Just as my eyes did not adjust with the passing of time to the absolute blackness of my surroundings, my stricken soul did not fail to experience a mounting fear, moment after moment an increasing sense of panic-terror, driving my blood in torrents into my throbbing temples which I longed to soothe with my fingers, but I was manacled to a stake in the cold, slimy earth, my wrists, neck and ankles chained in iron. Finally, I experienced an indefinable wavering of the darkness before me, and somewhere a distant part of myself realised I was swooning; swirls of grey dots and arabesques danced before my eyes and my ears pulsed with the whirring of beetles' wings, the noisome stench of decay lifting itself toward me with a vaguely discernible phosphorescent outline. Was this image part of my sickness? — or did it belong to the greater pool of sickness which swam all around me? — I had expected the sharpness of rats' teeth, the teeming vermin of the cell, to gnaw at me eventually, but these attacking protuberances, though sharp in their icy, corrupt whiteness, yet crumbled like soft, decaying putty when they touched my screaming face. As my voice faded away to my own hearing, I thought surprisingly coherently of the pale beatific face of the dead man, its mouth now a broken, gaping hole.

The Repeated Journey

JOURNEYING along the coast I think: this is where it will happen again.

Outside the roughened wall, my fingers ran along the shingle to the small, round window of stained glass. In the sunshine the stones in the garden looked as dull as the interior of the house.

I had arrived a few hours earlier. It was spitting with rain in the wind. Mrs. Peterson opened the kitchen door and insisted on carrying the smallest of my bags to the stuffy attic room. The bed had a colourful quilt that clashed with the yellowing floral wallpaper and the old furniture, thick with layers of polish.

"Very nice, indeed," I ventured.

Mrs. Peterson's dentures clicked as she smiled.

After a glass of water, I decided, at Mrs. Peterson's suggestion, to look around the large garden.

I watched the sun appear through parting clouds, projecting its fractured beam through the iron railings into the mound of the compost heap. Here a small structure of dead sticks made a shadowy marker like a tombstone.

Later, up in my room, I heard Mrs. Peterson strike the gong for dinner.

The dining room was dark and dusty; the old woman was slowly

sweeping up and clucking her tongue. Plates of tomato soup were on the table next to a mound of dark, crumbling bread that reminded me of the compost heap. I sat and let my fingers crawl toward the plate.

Soon, two other guests seated themselves, smiling politely: a middle-aged couple who called Mrs. Peterson Clara..

"WE'VE BEEN coming here for many years," they explained.

I tried my best to eat the stodgy food unselfconsciously, but I felt as though Mrs. Peterson and her guests were watching me all the time, awaiting my look of approval with expectant gazes. Finally, I finished off the apple sponge.

"I can offer you a drink, if you'd like one," Mrs. Peterson intoned reluctantly.

BACK IN the small attic room, I unpacked my clothes and lay them out in the newspaper lined drawers. I placed the picture of Alison on the bedside table, next to a foul pink reading lamp.

THE SKY was darkening. I peered out at the row of jagged cliffs, where a gang of teenagers larked about with an old boat. Beside me on the bench, a carton of orange juice had gone soft and soggy. Fairy lights on the distant pier marked out the shape of the large hotels further into the town centre; distant voices barked like dogs over a cascade of discordant music.

"Not as pleasant as it used to be, you know."

The middle-aged couple seated themselves next to me on the bench, discarding the punctured orange carton onto the grass. Just then, a long, colourful toy train, scaled up to life size, passed by with a few children aboard, seated like dreamers looking out solemnly over the choppy grey sea. Then, I realised they were wearing masks.

For a moment, the faces of the other guests were superimposed with the same lifelessness, but then the illusion passed.

"By the way, I'm Arnie and this is Nancy," the man said. I reached over to shake their hands and found them both eager to grasp my fingers at once. The situation became embarrassing. I withdrew my hand and continued to stare out at the sea.

LATER, I regretted telling Arnie and Nancy about Alison, but the words had just flowed out, and I did find some relief in talking about her illness and how she had died. However, when we arrived back at Mrs. Peterson's, I heard them muttering about me in the lounge, and Mrs. Peterson

began to fuss over me with knowing eyes. Finding all this insufferable, I went up to bed.

Of course, I found it difficult to sleep. Despite the open window, the room was unbearably hot and stuffy. At times, I thought I heard voices coming from below. Not just the voices of Mrs. Peterson and her two guests, but others. Some of them sounded like children.

Finally, I must have fallen asleep... In a dream, I was walking down the stairs toward the voices. Slowly, as I descended, I heard a regularised squeaking sound coming from Arnie and Nancy's room. As I emerged from the shadows in the hallway, I became more and more attracted to the thin sliver of light that escaped from their doorway. The squeaking increased in intensity and at last I smothered an impulse to laugh as I realised with some horror what they were doing ... and I had to look ...

Nancy was on top, facing the door, her small, saggy breasts heaving up and down as she towered over Arnie's pale, flat form on the bed. She threw back her head, beginning to moan though her teeth like a dull-witted animal.

"Careful, careful," Arnie said from beneath her.

With an awkward movement she reached for his knees, and he shouted out.

"Sshhh," he said to himself.

I began to wonder how Arnie had managed to fold his calves so expertly beneath Nancy's heaving, bag-like form when suddenly, with a start, I saw that his legs ended at the knee in two raw, purple stumps.

I EMERGED from a fitful sleep, slumped half naked over the bed. There was a sound from outside. It was the train. It had stopped directly outside Mrs. Peterson's gate, where a group of people were slowly boarding, the masked children amongst them. Were these the other guests I had heard?

I couldn't be sure, but it seemed everyone was wearing the same, lifeless mask. I watched the train until it disappeared among the trees into the darkness of the cliffside path.

"DOES THAT touring train run during the night?" I asked Mrs. Peterson at breakfast.

"No, I don't think so, dear," she said, smiling indulgently.

Arnie and Nancy glanced over at me, rather sheepishly. Could it have been because they knew I had caught them at it last night? But of course, that was a dream!

Why then, had Arnie placed a pair of crutches against a vacant chair? And hadn't Nancy moved that chair in order to wheel Arnie over to the table where he was now nervously eating ...?

MRS. PETERSON cleared

away the breakfast things. It had been raining since early morning, but now it was bucketing down.

I stared out at the garden through the open window, smelling the flowers and the grass, my mind blurred. There was a soft tapping at the door; it was Mrs. Peterson.

"I wondered why you looked so sad all the time — and so very well-mannered. That gives it away, you know . . . Arnie and Nancy told me about your wife. I'm very sorry, my dear."

"Yes. Thank you," I said.

"Of course, I'm very gifted you know. I thought, seeing as it's raining, if you've got nothing else you want to do, you might like to come into the parlour . . .?"

I STARED OUT over the red roof tiles at the tool shed and the wet, jagged shingles. Fingers of grass poked through gaps in the toneless, grey paving stones. My feet squelched in the light, canvas shoes.

The old woman called me in.

The room was full of smoke and dull with morose emotion. The curtains were half shut and pocked with mildew. Arnie and Nancy were seated on either side of a dusty round table, half-sticky with stains from spilt cups. I smiled nervously, and sat on a cushion overstuffed with dust, feathers spilling out. The room smelled of foam rubber and old women's streaks of piss.

MRS. PETERSON now had eyes like those of a bird. Almost immediately, after our hands touched, she began to roll her head like an old sea-tossed boat, breaking into a hard, teeth-edging voice, speaking about another room, like this one in all details.

I could tell the room in question was moving through her vision. She tensed herself like a person tightly bound and gagged, throwing herself back against the floral wallpaper on the crumbling chimney breast.

Finally she sighed; her face lit up with a beatific smile. "Ah, Alison . . ."

The moon had almost disappeared into dust and darkness. Staring round, distantly hearing the tapping of rain on the windows, I tried to see Arnie and Nancy, but they were obscured by a vague, fading light that gathered in front of Mrs. Peterson's face.

"Ah, Alison," she sighed again. Now the light formed itself into the lifeless face of the mask I had expected to see.

SOFTLY AT FIRST, "That's not Alison," I said. Arnie's hand began to crawl away, but I gripped onto it, regardless of the fact that he had begun to cry out. "That's not Alison," I said much louder. The mask hovered, its mouth an '0' shape that emitted a shrill, distant, musical voice.

"No, no!" I was now desper-

ate to pull away; loathing myself for agreeing to Mrs. Peterson's séance. I wrenched myself free of the table, yanking Arnie's hand with me, which tumbled to the floor. His shrieking torso threw itself in dismembered pieces onto the dust-pulpy carpet, his head a lifeless, eyeless mask.

Nancy was screaming, "Arnie, my Arnie!"

I stared down in horror at the carnage; at the faceless head and bloodless limbs.

"I'll get Arnie back for you, Nancy," said Mrs. Peterson, "I'll get him again. I can always get them back for people, can't I Nancy?"

I RAN FROM the house into the rain. The touring train was crawling along the cliffside. I ran alongside; slipping over the wet grass, gripping the rusty sides, I swung myself on board. Soon I would be in the town centre . . .

I MUST have passed out; though I am wet from the train seat, the rain has stopped. Journeying along the coast I think: this is were it will happen again.

But I don't care.

I am sagging heavily with water, my clothes soaked through. My shoes squelch on the brightly painted floor. In the gardens and against the cliffs, the wet, blue weeds are nodding down. I slowly ride this circuit all the summer through, where I wave hesitantly at the indistinct faces of all Mrs. Peterson's guests, lined up to welcome me back inside the rain-streaked terminus.

A Wild Time

AS WE GET nearer to the dingy collection of portacabins and plastic shells, we pass the St. Michael street social club and I throw a good size stone at the door remembering how last week we'd been thrown out. Some stupid cow had spat into Matthew's face when he'd tried to feel her up, but she was coming on to him so I couldn't see what the problem was. Anyway, he'd thrown his drink up her and slapped her around the head when a bunch of fuckers who looked like security guards from the estate had started punching and kicking him. Me and Tony set in on them, but we were outnumbered so we got a pasting — then we were thrown out and barred . . . As we run past, we kick their dustbins over at the end of the yard, and Matthew and me piss into the open topped sports car owned by the flashy barmaid.

There's not much to do so we're running down the street smashing some bottles we've found against the walls. I'm laughing, throwing my head back seeing stars in the sky, closing my eyes, seeing them again inside the sky in my head. Another bottle smashes.

"Fucking hell, that one was full!" We're howling with laughter. My jaws are aching. Matthew skids up an alley for a piss. Me and Tony wait there for a bit, quiet. I'm rubbing my bloodied knuckles where they've scraped against the wall. Matthew's taking ages.

"Come on fucking hell!"

"What was that?" says Tony.

Matthew's pissing about with us: There's a long, low moaning noise, a dustbin lid rattling.

"Fuck off Matthew, what do

you think we are, still kids?"

The moaning noise again, and the scraping of a dustbin lid. More time passes. Matthew emerges from the blackness looking wide-eyed. We look at him. His face breaks into a smile.

"Look what's down here," he says.

We go into the alley. It's full of rubbish and shit as usual. But somewhere in the middle there's a really skinny kid slumped over a dustbin. When we get up close, I can see he's alive, but there's blood and sick all over him, and his eyes keep rolling up.

"So that's what was making those moaning noises," I say.

Matthew prods the kid with his finger and it moans again and sort of shudders. When it opens its mouth there's the most terrible stench.

"Oh fucking hell," says Tony, putting his hand over his mouth, but he's still laughing.

My eyes are adjusting to the darkness now, and I can see the kid more clearly. He's naked and bald — in fact there's no hair on him anywhere — and he's so thin he looks like a skeleton. He's gripping his fists so tightly you can see the tendons in his arms like spaghetti.

"He's one of those fucking leukaemia kids," says Matthew, "the hospital must've dumped him here . . ."

"Yeah," I answer, "Yeah, cause they must've thought he

was dead. Fucking hell, what a stroke . . . of . . . bad . . . luck!"

I begin to laugh again and Matthew's face cracks into that wide smile of his. Tony's having a piss further up the alley. A second or two passes. Then he shouts "Oh Christ, what the fuck am I pissing on?"

He's pissing on a pile of skin and bone by the look of it, pissing on a pile of the kid's dead mates. Good job the kid managed to crawl out of the pile.

"What're we going to do with it?"

"Throw it back on the pile and forget it," suggests Tony, "it's not our responsibility."

"No," I say, "let's carry it into the street and have a better look at it first."

As we're carrying it down the alley, the stinking thing begins to moan in a high pitched voice like a cat, a stench emanating from its mouth like I can't possibly describe. It's like it's crying and shuddering at the same time, as though it's just a deflating balloon of skin. When we get into the street Matthew loses his temper and kicks the thing in the side of the face. The whole head caves in and there's no doubt whatsoever that the kid is dead.

"That's certainly fucking that!" says Matthew, looking a bit disappointed.

We stand staring at this deflated mess for a time. Then I notice its hands again, gripping

tightly into fists. It's holding something. I remember what I've heard about rigor mortis and stoop down suddenly, trying to prize what ever it is out of the dead things hands.

"What the fuck're you doing?"

"It's got something in it's fist, c'mon!"

The fingers hold on tightly. We can't budge them. Tony goes into the alley and comes out with a big sliver of glass — swearing — he's cut himself on it already.

"Stupid fucker!" He throw the glass down and it shatters into a beautiful pattern. "I'll get another piece," he says.

We cut the kids fingers and they come off easily like foam rubber. More of that horrible stench. I'm beginning to feel high on it, my eyes are getting bigger, I want to laugh. It's a real effort for me to concentrate for another few seconds, then suddenly my head clears. "I'm O.K." . . . "What's he fucking going on about?" Matthew and Tony are laughing at me. I grin up at them. I'm holding the little box I've managed to cut from the kid's fingers.

"What's that?"

"I don't know." I clean the sticky blood off it and see its got some sort of trademark on it and the address of a chemical laboratory. I grin at Matthew and Tony again. "It's some sort of drugs," I say.

We look at the packet for a while and begin conjecturing about its missing contents.

"Kid must've taken his medicine too late . . ."

"Perhaps he O.D'd on purpose, or something . . ."

There might be some more stuff in the alley . . ."

We look around for ages but we can't see a thing. Eventually we drag the dustbin out of the alley into the street. It's got the same trademark on it as the one on the packet. We begin to search through its contents, finding more of the boxes, all empty. The smell's enough to knock your head off. Then we realise its not coming from the dustbin, it's coming from the kid who has now begun to froth and hiss, erupting into a lava of slime like a salted slug. The stench is overbearing. We drop the boxes and run up the street. What the fucking hell had been wrong with that kid? . . .

It takes ages for the stink to clear. We're sat quietly on a wall. I'm looking up into the clear sky at the stars. I feel like I need drink, wishing I hadn't smashed that full bottle. I start thinking about the little box the kid was holding.

It strikes me that the address was one of these new units on the industrial estate . . . I make a move, excited by a flurry of ideas racing around my head. We set off at a run, throwing things at the walls again, heading for the industrial estate.

Xenos

THE CARS were lined up, row after row. Mary fumbled for her keys with trembling fingers and unlocked the car door; she jumped in quickly and drove out of the shadows into the sunshine.

She hated the dark. It made her understand how those mistreated children felt, locked up in a dark, tiny space, bloody and bruised . . . she shuddered as her car ran into file awaiting the changing colours of the traffic lights. Mary had a lot of studying to do. This section of the sociology course was the most disturbing and, she thought, the most vital. Some of the other students didn't seem to be taking things as seriously as Mary, but that was their lookout. She had heard a few of them in the refectory cracking tasteless jokes;

well, that was a bit *too* much . . . maybe if they had been kicked around (and worse) from babyhood right up to infant school age, they wouldn't have been so eager to laugh.

WHEN MARY got home she unpacked her books, deciding to read until she was ready to prepare something to eat. She took a few slippery, cold cups out of the grease-lined bowl, emptied the smelly water away and splashed her face with fresh water. As she dried, she noticed one of the books with surprise because she couldn't remember seeing it before. It was brand new. The library hadn't even defaced it with stamp-marks and stickers; there was no shelf number on its spine. Mary opened the book hesitantly,

wondering if this was another tasteless joke, but found its contents immediately riveting. It was about William Fenwick, the notorious child murderer. Mary glanced at the publishing data opposite the title page; all it said was

NEWLAND PUB., June 1989

No ISBN number or copyright warning.

IT WAS seven-thirty when Mary realised she hadn't eaten yet. The book was insightful, scholarly and absolutely fascinating. Mary daren't quite admit it, but it was also *exciting* — in a morbid, distasteful way, of course. As she got up to make a sandwich and a cup of coffee, she pondered on the details.

William Fenwick had been a normal sort of person, not a slavering fiend, not a noticeable pervert. He was forty-seven-years-old on the day the police stopped his car on a routine traffic surveillance (Fenwick had been speeding a little over the limit) and found the strangled boy, Darren Carl Walker, in the boot of Fenwick's car. Fenwick went along quietly with the police — later there was some evidence to suggest the police had beaten him up, breaking his wrist (but never mind about that).

Fenwick had pleaded guilty to murdering the boy, along with eighteen other children on the police's reported missing list. The bodies of the other children, all aged between two and ten years old, had never been found.

Mary sat down to read again. Fenwick couldn't be tried for the murder of anyone but the Walker boy, of course, though his statement was readily taken into account. In another paragraph, Mary noticed with a little disappointment that Fenwick would never be re-tried — three months into his twenty-five year sentence, Fenwick had hanged himself in his cell. The missing children, all eighteen of them, would never be proven to be Fenwick's victims. Mary shut the book and closed her eyes, tired from reading.

It had grown dark and oppressive. Beyond the window black clouds hung menacingly, causing deep shadows in the hollows of Mary's thin face. Staring in the small mirror that mounted the overlarge fireplace, she stood in alarm, studying her gaunt features. Her face looked like a skull; when she opened the slit of her thin, wide mouth, the darkness poured in and filled her throat with broad brushstrokes of night. Quickly, she switched on the light, disturbed by the picture the darkness had painted: Mary as a pinch-faced ghoul. She

43

couldn't help thinking her face must now look like the dead face of the murderer William Fenwick. Glad of the light which dispelled this illusion, Mary sat back, exhausted. Though the book had said differently, Mary realised with intuition sparked by the horrific illusion that Fenwick had not been an ordinary man — who were the authors trying to fool? Fenwick was a child murdering rapist, a fiend. With some consternation, she realised it was the vision of her own death-like face that had proven this assertion. She shook her head with confusion and fatigue. It was time for bed.

THE NEXT DAY Mary awoke to brilliant sunshine. All the previous night's melancholia had passed, leaving her feeling renewed. Driving to college was usually a boring task, but today Mary relished the hazy warmth and the stream of traffic and the shouting children running to school. But suddenly, an image flashed into Mary's mind that she swiftly dismissed with a shake of her head. She swung the car, turning left, smoothing the flash of pain from her forehead — it disappeared quickly, and she made the effort to smile again. The road stretched ahead into the distance, straight and narrow, climbing slowly.

Ten minutes passed before Mary realised her mistake. She should have turned right at the lights. The road before her seemed to go on and on without diversion. Huge clumps of ripe green foliage lined the hedges; weeds as tall as Mary grew in dense rows, rank and moist. The sun poked its beam through thick ropey trees, fans of branches spread like pulsing veins. The car broke through a strand of cobweb that glinted in the sun. Mary instinctively lowered her head, as though it would decapitate her like a wire.

There was no lay-by to stop in to take stock of her position. As she drove on, the density of foliage began to resemble an oppressive, crumbling wall, light from the obscured sun appearing in ancient cracks in the masonry of grotesque weeds and poisonous nettles.

Mary had not seen another car since she turned onto the road. She hadn't seen a single pedestrian. With little bubbles of panic rising, Mary stopped the car, pulling in as near to the roadside as she could. She rolled the window down; everywhere was totally silent. There was no breeze to shake the putrid undergrowth, but the stench of rank humidity hit Mary like an explosion of rot and corruption. Wiping her hands on her skin, she climbed from the car and surveyed the pitted road with its crumbling surface of little twisted roots. In a futile, illogical gesture, Mary

took the Fenwick book from her bag and threw it into the ripe purple thistles.

SHE HAD been walking for some time; earlier when she returned to the car to attempt to turn it around, the engine had given a sickly shudder and died. After an hour of useless deliberation, Mary decided to walk ahead into the flowing shadows.

Light broke through in dusty vortices. Mary was aware of the effect it would have on her thin, shrunken face; she was reticent to peer too far into the faded light, in fear of catching a glimpse of herself in the droplets of oozing moisture. She felt sick and afraid in case someone else should see her face and accuse her of Fenwick's crimes — but why should they? Mary did not understand her feelings; she felt panicked, because she knew somehow that something had begun in this place that must continue. Her morbid reverie was broken as she noticed with a start that the house suddenly rearing into her vision was familiar, even though it was distorted by trees and distance. Of course! It was the house on the cover of the Fenwick book, she was sure. The book did have a photograph of a house on the cover, didn't it? Or was it a drawing? Mary clawed at her hair, pushing it from her face in moist strands; her scalp oozed with sweat. She began to feel submerged in the ripe, green stench of the undergrowth. She hadn't noticed before, but now the road had completely vanished. The last stretch leading to the house was obliterated by a tangle of knife-sharp grasses, but at least here she was out in the open again, thankful of the light rain in the humid air.

By the time she had fought her way through to the house, Mary was exhausted. She slumped down before the cold, grey portal, studying the looming edifice crumbling upwards into the obscured sky. Without wasting time, Mary pushed open the wet front door, which pulled a taut mesh of rotten framework along with it, collapsing into a fungal garland within the hallway. Mary tried to examine her feelings, but no thought would come. She was aware of her trembling hands, aware of what the new darkness of the interior was doing to her face . . . She began to check each room, like an automaton, obliterating each new pang of dread that emerged within her, forcing herself to be methodical, assured that she would soon discover what she was looking for. Each room proved to be empty, except the basement.

A steep descent of broken steps led Mary to the tomb of the children. In cross-hatchings of light flowing from a gridded window, a montage of mummy-like faces, little wrinkled hands, legs, feet,

bones dull with cellar filth was revealed; a rotten pile of execution victims. Mary slumped down on the steps and covered her face, moaning to herself. When a dry little hand touched her, she did not raise her head.

SOMEWHERE above them, a toneless, thudding bell was ringing. Each step they trudged was littered with instruments of death, a plethora of knives, gouges and hacksaws; long metal needles covered in sticky filth that clattered beneath the procession's feet. Mary knew where they were going, she would not be led by mere children. She headed swiftly for the bell tower.

THOUGH THE thing was partly obscured by darkness, Mary could see it wasn't as terrible as she had expected. Its dark, blotchy form might have been reptilian, but it wasn't solid enough to be sure. She allowed herself to smile, glancing at the children; seeing them in the way the thing saw them, she could understand its joy. Like her, the children were altered by the thing's light. It's urge to feed, its *need*, no longer repulsed Mary. She thought the thing felt relief, as though it needed acceptance as much as it needed the children's life-force.

Mary realised this strange creature had once been a god. In the days when people were willing to offer a sacrifice to its strangeness, it had thrived, though it had been misunderstood even then. Now, the thing, an intruder saddened by rejection, needed looking after. Fenwick had tried his best; she would do better.

MARY WAS pleased to receive a good grade in the final exam of her sociology course. The summer stretched ahead now, and it wouldn't be too long before she was placed right in the hot bed of action. She had been accepted as child-care officer for the social services department. Funnily enough, she hadn't even needed to obscure her face too much, no one seemed to notice the thing peering out at them from under her skin.

She had tried several times to find the house again, but no matter how she tried, she could not even find the road that led to it. But that didn't matter, she could easily feed the thing without the need to enter its dark, claustrophobic domain. Mary would bring everything out into the light! She turned to the little girl in the seat beside her. "That's it, oh yes, touch yourself *there*," Mary said, feeling the bolts of energy running up and down her spine, making it tingle.

Going Away

WE WERE breakfasting late. It didn't matter much. The Walpole Bay Hotel was empty apart from ourselves and two old ladies, both of whom looked like they might have been called "Mrs. Wilberforce, widow of Colonel Wilberforce." (The only difference between them was that the one was wheelchair-bound, whilst the other had an aged boxer dog. Apart from that, one couldn't tell them apart).

It was early September, one year after the war, and still quite warm in the sunshine, when it finally broke through the cover of mist, which, at this time of year, tended to linger on late into the morning. I stared out through the ornate archway of windows, past the brief facade of the conservatory, out onto the promenade with its dew-covered bowling greens. Already, an old man and woman, both bedecked with white flat caps, were bending and stooping in accordance with their game.

"I suppose it makes it more interesting if you have to guess where the jack is," I gestured to Alison, but she was lost in wan thought, her white, pleasantly studious face pinched by fatigue. I touched her hand — "Are you alright?" She smiled.

"Have you been dreaming all night again?" I tried to tease her, as though it were really her own

fault, but the look she gave me made me give it up.

"Was it the same dream?" I asked more seriously.

"Yes, exactly the same." She replaced a strand of her straight, fair hair that had strayed, and made a visible effort to shake herself from the grip of the dream. The waitress removed our grapefruit dishes and shortly afterwards returned with the bacon and egg, and all the rest of it. My appetite, compared to Alison's lack of it, made me feel vaguely abashed.

BY 10:30, or so, the mist had lifted. We walked along the promenade towards the shops where Alison wanted to buy something she had seen the day before. It was a little figurine of a black boy holding a fishing pole with a fish on the end — the type of thing that was in vogue at the time in seaside towns, mass produced for the visitors (one didn't refer to them as 'tourists' in those days.) Alison had an Aunt whom she thought would like the figurine . . .

"I'll bet that Aunt of yours doesn't get to see hide nor hair of it," I joked as we walked along the multi-coloured pavement stones. The tide was half way in, accompanied by a light breeze, and the sun was beginning to shine. Alison leant her head on my cheek, screwing her nose up as she laughed, but almost as suddenly her expression became vacant again, and I felt her being pulled from this world into another by her troubled thoughts.

"You can tell me about it again, if you want — in greater detail, if that would help."

"Well, well — it was just the same thing again," she sighed. Then, with more determination; "but I *will* tell you again, if you're sure you don't mind."

"Good, let's sit here for a while. I think it's warm enough to sit."

Alison recounted her dream, her constant nightly companion over the last two weeks:

"Again I was walking across a village green where there was a cenotaph surmounted by a badly worn figure of a soldier. The top of the bayonet was broken off. Everything was so tactile — my feet were bare and I could feel the dew on the grass."

"Got your feet out of bed — cold," I muttered.

"Yes, perhaps, yes," I could see she was irritated by the interruption. I apologetically gestured for her to continue.

"Now, I ran again to the other side of the green where I could see shapes in the dark; trees, shrubs, houses. But away from the cenotaph everything was dark, very dark. It's at this point in the dream I always start to be afraid. Not much, at first. But the feeling mounts up. It mounts

up and up." She stared ahead a little while, so I took her hand, urging her to continue.

"There is a gate and the suggestion of a path and before I know it I'm standing in a porch before a door. I never want to try the door, but I always do — and it's always open. For some reason, even though I'm full of trepidation, I still *run* into the house. I don't walk I *run*. Even though, by now, I'm very afraid. And I know I'm afraid because I'm going into the house, but I can't stop.

"The hallway is spacious, wide. I can just make out black and white tiles, cracked here and there. The floor is littered with old leaves that must have blown in under the door. I run around the circumference of the hall until I find a light switch. There is a lamp on a table, plugged in, and it works.

"I don't see the mirror at first. Instead, I turn and see the staircase. It's one of those magnificent, huge things you see frequently in old houses. I take a few steps up, until I notice my way is barred by some packing crates, you know, old tea chests, full of pots and odds and ends. I turn around. Oh God, and that's when I see the mirror, to the left of the lamp by the side of an open doorway — oh, and I'm so frightened of that mirror, so afraid that I shall have to look into it. I stand there for ages, until I'm so

cold I can hardly move at all. Then, I take myself by surprise: I suddenly run towards the door — but then, but then! I realise -" She shuddered, eyes wide, her mouth turned down in a peculiar grimace, and I held her close to me murmuring and shushing her and kissing her hair, but I felt I couldn't really reach her.

"— I realise the geometry of the house has changed to trick me! The door I'm running towards is the open door, next to the mirror. And then, it's too late. I see myself. It's a full length mirror, no frame, mounted on the wall like a clothes shop mirror, you know, but there's something terrible in it, rushing towards me, rushing towards me!"

She trailed off, her shoulders slumped a little and she exhaled, a long breath. "And then, oh, I don't know, nothingness, blackness, nothingness."

Alison slumped a little, and then covered her face with her hands. I thought she was going to cry, but then she drew herself up, sighed heavily once more, and then turned to me, offering the faintest ghost of a smile. I was touched by her effort. I smiled back broadly and she kissed me.

"Oh I don't want to appear insensitive darling," I said, "but you do realise that despite everything it is just a dream." She nodded slowly, delicately, unconvinced.

"Yes, but every night since we

came here," she said, "nine, no — ten, nights in a row!"

"I'll admit that certainly is very unusual. There must be some reason, some unconscious trigger. But heaven knows what it could be. Now, don't be annoyed, but we can go home early you know, if you want to. There's no crime in that."

"Oh, no, no," said Alison, "I don't want to."

After a few moments of silence, watching waves, seagulls, children playing, she turned to me and I thought she looked a bit better, as though recounting the dream again really had helped to purge some of her anxiety. She must have noticed the relief in my face because she became more animated, sitting forward, pointing out a distant hotel that the strengthening sunlight had managed to isolate. At this point we saw the boxer that belonged to one of the old ladies, and became alert to her presence in the vicinity. There she was, pushing the other old lady in the wheelchair along the promenade towards us. They were both arguing animatedly over something, so we got up quickly before we were noticed, laughing, ducking into some ornate gardens.

"Let's have a cup of coffee," I said.

With coffee we decided to eat a light lunch, and I was heartened to see Alison partaking with some enjoyment. The little cafe was empty of other customers and we enjoyed the intimate silence, quietly planning the afternoon ahead.

Out on the street, the noon sun was pleasantly bright and warm. We set off to find the little shop we had seen on our first day in Walpole Bay.

"I think it's down here." I pointed down a steep cobblestone alley by the side of a large, free-standing public house, freshly whitewashed with blue painted woodwork. The alley led to a small square, surrounded on three of its four sides by cottage-style shops. But what immediately drew my attention was a war memorial in the centre of the square, surrounded by a low iron fence. I hadn't noticed it when we had been here before. Alison gave the cenotaph a glance, looked at me sideways, squeezed my hand reassuringly, and headed directly to the shop only to utter with dismay, "Oh no, look Gerald — it's closed!"

"Let's see," I said.

The shop was not only 'closed today', it had been stripped of interior stock and decor with the thoroughness and finality of all such failed ventures.

"They're packed up," I said unnecessarily, "these seaside places come and go in short order — and it's the end of the season."

"Look, here," said Alison. There was a note stuck to the in-

side of the door, just legible behind the dust darkened glass:

SOME OF THE STOCK IS AT
MEMORY LANE 15 PINFOLD
ST. THANK YOU.

"Well, right then. We'll go and see."

"It's not really all that important," said Alison hopefully.

"I should say it is!" She appreciated the mock-reproach and we set off. I had no doubt we would see another of the little black boy knick-knacks in one of the many shops on the way, or something equally appealing. But Pinfold Street was not as far away as I had somehow imagined it to be.

AT THE OTHER side of the square, between two houses, was another cobbled alley, and this led onto a residential street I recognised, which sloped down towards the town's shopping centre.

"I think if we go down here . . ." I began, but Alison had stopped. She was standing at the foot of another alley which divided two blackened, abandoned-looking terraced houses. At the top of the entrance there was a rusted fairground-style sign which said 'memory lane'. Beneath the lettering a hand with an outstretched finger pointed down the alley into darkness.

"Look!" Said Alison, beaming.

A large '15' had been painted on the bowed and damp-warped front door. "This must be it," she concluded happily.

As I led the way down the long, dark passageway I couldn't share Alison's light-heartedness. In the last few moments I had begun to feel distinctly nervous, and foolish with it. When Alison suddenly reached to kiss me, I actually jumped with alarm.

"Gerald?" She asked concernedly — but we were already at the end of the alley looking at a very wide, very deep, weed choked yard. At the bottom was a big one-storey workhouse, perhaps an old stable, declaring 'memory lane' on a banal make-shift sign made of corrugated cardboard.

"This looks abandoned as well," I said rather hopefully.

"Yes, it does," said Alison, "but let's at least look while we're here."

There was a narrow side door with flaking green paint, half-blocked by a precarious pile of old boxes which we had to side-step with great care. All the while Alison was squeezing my hand and uncharacteristically giggling with suppressed excitement.

"Good God, doesn't it smell in here!" She laughed.

"It's musty," I said, "it's all these old boxes. They must be damp-through."

The interior of the place was dim; only a small amount of light broke in through the low, dusty

window which was obscured by a combination of thick old cobwebs and an arrangement of various small household objects — a casual glimpse at a badly tarnished candlestick-holder proved it to be hopelessly worthless. One got the curious sensation of being in a cellar chamber, far below the surface of the earth, with generations of cast-offs and broken old rubbish put down there, out of sight, out of mind. Two old tables, common little drop-leaf things, were covered in a dense layer of dust, as thick as mouldering earth. There was a pot doll's head, hairless, with only one eye, an old sword, it's leather scabbard worn to baldness, pocked with serrated scars. Nothing at all but worthless, decaying junk, neatly arranged like fine collector's items from Kensington High Street or Knightsbridge. It was the most absurd thing I've ever seen.

"Look, I don't think there's much point looking any further in here," I said, "besides, it's so cold."

"Perhaps you're right," said Alison in her most disappointed voice, but just at that moment a light flickered into view, and we both turned our attention towards an old man with a paraffin lamp — he was standing behind a rusted filing cabinet smiling vacantly at us. There was an awkward moment before he spoke:

"Don't be embarrassed, please. Have a look, have a look. Anything you can't see, well, just ask."

His voice trailed off. He set the puthering lamp down and pretended to sort out a few of the smaller items, all the while keeping an eye on us as we made a desultory surveillance of the jumble on offer. He was an extremely odd-looking fellow, with a soft, crushed velvet fez surmounting a brown, wrinkled face, like the face of a midget, pinched and swollen, with only a pretence at good humour. He wore a thin purple smoking jacket, trimmed in red, which matched the fez, and a pair of green pyjama-style trousers. But his most outstanding features were his eyes; a most vivid amber colour, almost orange in intensity, and his hands; long and wrinkled like screwed-up brown paper, covered in rings of all kinds. And yet he did not fascinate, as one might imagine. Rather, I felt I absorbed these details about him routinely, without surprise, overwhelmed instead by a cold atmosphere of boredom; of long, tedious, lonely years — so that I could do little to disguise my impatience when I said: "Come on, Alison. I doubt very much we shall find what we're looking for in here."

"That!" Chirped up the old man in a feeble attempt to simulate the tone of a fairground barker, "depends on what you

might be looking for, yessir, what you're looking for!"

To my astonishment Alison let out a shrill cry of glee at this, and leapt delightedly almost clapping her hands in excitement straight towards the old man who stood there grinning, showing her his off-white, rabbity teeth.

In equal proportion to the annoyance I felt, there was now an unexplainable pang of fear and loss. I didn't know whether to strike the old man and pull Alison away, or burst into tears. I felt ridiculous, humiliated, abandoned. Alison was explaining to him about the figurine of the little black boy. He was nodding vigorously. He inclined his head towards her. She touched his arm momentarily. Then, he laughed and looked straight into her eyes. She laughed in return, hesitated, and then went on talking. He nodded solemnly, caught her eyes again, smiled. Alison laughed again, swayed back, and touched his arm again. Finally, he shuffled away.

"What's going on?" I forced myself to say. Perfectly normally Alison said: "Oh, he's gone to look for me! Gerald, won't it be nice if he can find one for me?"

I couldn't believe she hadn't noticed my distress, but at that moment the old man returned with a small square box which he had started to unwrap. At length, he produced the figurine for Alison to examine. Then he returned it to its box, smiled at her, and turned his eyes on me.

"How much will the young lady pay for this item?" He smiled insinuatingly. I felt myself saying stupidly: "The young lady is my wife."

"How much will the young lady pay?" He smiled again.

Sweat began to trickle down my temples. I shook with rage and fear. Then he laughed. "Five shillings and seven pence," he said, "is that too much?" Alison laughed again at his patter, and I felt even more ridiculous; utterly stupid, because now I could see he had been joking with me. He gave me a little apologetic smile, a contrite look, and a humble gesture indicating that he hadn't really meant any harm . . . All this in full sight of Alison, leaving me embarrassed and ashamed. But then, as he placed the box in Alison's hand he turned to me and at once the most hideous grin transformed his face; hideous because it contradicted the intense fierceness in his eyes; hideous because I knew Alison couldn't see what was happening.

"Going, going, gone!" He said, accepting the money from Alison without turning his head. He raised a little auctioneer's gavel: "Going, going, gone! Gone! Gone! Gone!" He said, banging the gavel down repeatedly.

The next day we decided to go home. It was a little early, but

all things considered, we decided it was for the best. That afternoon, after we had left 'memory lane', I found myself secretly — and guiltily — relieved that Alison had reverted to her usual withdrawn nervousness. I felt concerned for her, but I couldn't have stood any further evidence of her hysteria-based indulgence in the old man. Neither could I, on seeing Alison then, accuse her of flirting childishly with him. I was tempted, but all the colour had drained from her face, and she clung on to me desperately, like someone suffering from a dire sense of vertigo. After a time, she seemed to build herself up, as though for one final effort, and said to me, "Look, Gerald. Look at the box."

The neatly etched scene depicted a village green, a square of grass with a cenotaph in the middle. A figure of a soldier with a broken bayonet. In the background, leafy trees, shrubs, the suggestion of dark, looming shapes — houses. Underneath, an inscription read, 'Lower Bempton.'

When we got back to the hotel, Alison almost collapsed onto the bed, deathly white, eyes closed. In a matter of minutes she was breathing deeply, soundly asleep. I awoke her later to tell her it was time for dinner, but she only murmured, "mmm," nodding her head. "You go down," she said, and fell imme-diately back to sleep. She was still asleep when I came back an hour later, so I undressed her as best I could and put her under the sheets. I wrapped an eider-down around myself and tried to read the newspaper for a while in the chair by the window. Once or twice I heard Alison laugh out loud, only to then abjectly say to herself, "Oh no, oh dear, no, no". A little time seemed to pass and then I opened my eyes with sur-prise. It was morning: 7:30. My neck was stiff from where it had rested awkwardly against the back of the chair. I looked out at the morning mist, at the fine spray of drizzle on the window, and shivered. A knock at the door announced the arrival of morn-ing tea.

WE DECIDED to breakfast as early as possible in order to get away quickly. As we waited in re-ception, one of the "Mrs Wilberforces", the old lady in the wheelchair, wheeled herself to-wards us.

"Not a very pleasant morn-ing," she said, "however, I still must say 'Good Morning'. Are you two off to do something nice today?" It was the most she had said to us throughout our stay — not entirely her own fault as we had kept running away from her! — but I still felt she was angling after something.

"Unfortunately not," I said, "I'm afraid we're going home af-

ter breakfast."

"Oh what a shame!" She became conspiratorial, "especially as I was going to ask you, my dear," she turned to Alison, "if you would purchase a little gift on my behalf for Miss. Moreton — you know, *my friend*," she whispered the last part with the same emphasis someone would give to an insult. "She has been kind enough to help me around this week and I would like to repay her in some small way. But," she sighed, "no matter."

I glanced at Alison, and she nodded. A few minutes later I returned with the little black boy and presented him to the old lady.

"For Miss. Moreton, " said Alison, "please."

"Are you sure? Well, let me see — quickly before she arrives!" She removed the figure from the box and her eyes lit up. "Oh yes. Yes indeed! How lovely. Are you sure you don't mind?"

"Not at all," I said.

She glanced at the pencilled price and graciously said: "I must give you six shillings for it, and please — no arguments!"

The transaction was completed. The old lady beamed at us with delight, as though she would like to confess to a deep secret. Finally she spit it out: "It's just that, well, I'm almost tempted to keep him myself, as I have one just like him at home. Only, he's a little soldier standing to attention, and, you see, the tip of his

little sword has broken off."

AT THE BREAKFAST table I looked at Alison. There was a sort of resigned listlessness in her eyes. Still, she ate her breakfast and conversed normally, even managing to smile occasionally. I drew attention to the old couple with the white caps playing bowls behind us, while the windows rattled steadily as the rain sprayed them in gusts.

"At least I didn't have the dream last night," said Alison eventually.

JOURNEYING HOME: Away from the coast the overcast sky cleared, and where before there had been rain, now there was just uniform grey dullness. Alison spoke very little, except in response to questions, but when she did she seemed cheerful enough.

In those days, when a few people still called it motoring, journeying by car was a different affair than it is today. Little winding, round-about routes were the norm instead of motorways. There was relatively little traffic. It seemed easier to get lost, and harder to be found.

We must have driven round and round in circles for hours without seeing a soul. I had the feeling that I'd taken the same wrong turn as I had taken on the way to Walpole Bay two weeks previously — without such dis-

astrous results. Eventually, as I knew it would, our little Hillman came to a juddering stop. The petrol gauge showed the tank to be empty. It was cold and grey outside, getting ominously dark. Alison smiled briefly, reached for my hand, kissed me. If I had admitted it to myself, I knew then she was looking at me as if to say good-bye. I touched her hair and I kissed her hand and got out of the car. I lifted the boot up and looked for the petrol can. I emptied the last few dregs of petrol there was in it into the tank. I put the can back in the boot and slammed the lid shut. I did all this automatically, with the gnawing inevitable fear that when I got back into the car, Alison would be gone. I forced myself not to look. Not to give in to such ridiculous notions. Even as I knew she would be gone, and at the same time knew such knowledge to be absurd, I just stood there frozen by indecision, stood there letting terror wave over me, and I actually closed my eyes and crossed my fingers and wished. And when I opened my eyes and looked into the car, Alison had gone. She had gone away.

SOMEONE ELSE might have run after her. I knew instinctively where she had gone; through the roadside hedges, down the steeply sloping fields, into the pastures beyond. But I followed slowly, knowing she had already gone away from me forever. There was no point running. I couldn't run as fast as Alison.

When I came to the village green, I recognised it straight away. There was the cenotaph surmounted by a soldier with a broken bayonet. Here and there a few weeds protruding from the wet grass in the growing darkness. By the time I reached the gate of the house, hearing Alison saying forlornly, "It's at this point in the dream I always start to be afraid," it was fully dark. I pushed the gate open, walked up the path, my eyes on the door of the house.

I stood. Like Alison. Not wanting to enter, and then automatically entering like dreamers do. I saw the black and white tiles, the wind-blown leaves, and I saw the lamp illuminating the stairs. I walked slowly forwards and then I walked slowly upwards, up the stairs to the packing crates and old tea-chests — full of pots and odds and ends. Old jumble — and hundreds of little 'Lower Bempton' boxes, which I knew contained duplicates of the mass-produced figurine of the little black boy. The same sad knowledge that this image had broken the cycle of Alison's dreams on our last night at Walpole Bay — that her sleep had been dreamless that night only because something had ended, not because she was to be freed.

Then, I turned and faced the

mirror: her point of fulcrum where her present-self had met its predicted future image, and where the two had merged, producing nothing, cancelling one another out, forever — "Nothingness, blackness, nothingness" . . . Alison had said.

As I sat on the stairs, covering my eyes, blotting out the mirror, blotting out all the pain, feeling all alone, terribly and finally alone, I had an image of the old man from 'memory lane'. His eyes — his twisted, insinuating grin — banging down the auctioneer's gavel, he was saying, "Going, going, gone! Going, going, gone! Gone, gone, gone! Gone, gone, gone!"

In the... doll-drums

SATANIC LIGHTS gleamed in bottomless depths. Jungles of mingled shadows, all the shades and contours of a grey anti-spectrum. As if everything, so formless, was yet made of stone.

It had been elementary hypnotism. At first the doll hadn't meant a thing. The verbal instructions had sunken her down into another self of greyness. A person in a hypnotic trance, the mesmerist had merely demonstrated with the doll what the subject should do. Polite nervous laughter.

The skin of her face, emerging like a colour being slowly lit from behind, over long, mule-like bones, began to clear. A resur-rection was taking place.

IN HALF AN HOUR the blandness of the soiree recommenced. Ira tightened her grip on her cocktail glass, still grim-faced, dextrously forming herself whole in her mind's eye; a gift of Ego. All she could clearly see was the crude doll: "something new, as old as sin."

"I don't like it," she breathed, "what am I going to do?" Her mouth twitched nervously.

"And he objects to us marrying because of my social position," a voice was saying — or was she in the dark bathroom with only the mirror alight, talking to herself? She strained her neck.

"Ira, Ira? Do you still feel awful?"

So it *was* Marjory, not just her own reflection after all. Ira found herself escorted to the door for yet more fresh air. The trees shook. Silver and black. The mane of the sky.

"Don't let your mother see you like this, Ira!"

"Oh, she'll just believe I'm tight."

"Or that you were hypnotised by a scoundrel."

Don was standing beside her, taking her hand. Marjory rubbed her forehead. A few strands of her hair whispered. A strip of material from an old dress. For Ira and Don the party seemed to have melted away into abstractions of fear. Kerew, the hypnotist, was no longer in the room, but outside, with them, as part of the cipher in the landscape they were blankly surveying. When the wind blew they saw the effigy.

The Night Barge

THE HAND offered me a slip of paper, before withdrawing back into the darkness. I rubbed the sleep from my eyes and squinted at the neatly-written message:

COME TO THE DOCKS — 11PM
12 HOURS FROM NOW

I smoothed out the wrinkles, folded the paper as neatly as possible, and slumped back down onto the bench in the churchyard.

The day passed slowly.

In anticipation of what the night would hold, I paced up and down, examining the mildewed flourishes on archaic grave stones which obscured names and dates. Finally I returned to my chilly house, where I spent most of the afternoon trying to get the fire to go, tussling with paper, sticks and coal in an effort to produce the faintest, dim glow.

Presently, darkness fell and I left the house. It was only 6.30, but I wanted to make sure of keeping the appointment, even if it meant standing around for hours. Besides, I had nothing else to do. A short time after I had turned the key in the front door, walked along the narrow street and crossed the junction to get onto the main road, a large, black car pulled up and two men inside

asked me for directions to the docks. I explained to them that I was going there myself, so they told me to get in and they would give me a lift.

The journey was disturbing. The passenger in the front seat next to the driver kept turning round to grin at me as the driver asked questions and made comments.

"Where you from?" the driver said.

"I've lived all my life in this town," I answered, looking at the ancient, grinning man who stared at me, his eyes darkened by the brim of his hat.

"What are you going to the docks for?"

"Don't know," I wasn't lying really; "Just something to do . . ."

The grinning man widened his grin and nodded at me. His misplaced attempt at reassurance made me shudder, but still, I smiled back.

"Where do I turn now?" asked the driver.

I explained the best way to negotiate the route ahead, and as I did so, I was sure I heard the driver mutter to his companion to keep his hands in his pockets . . .

We eventually came to the winding road that led down to the docks, passing the ancient-looking street lamps and oil drums where small, furry shadows gathered. The driver's companion continued to grin at me, making obscurely significant gestures toward certain landmarks that left me with an indefinable feeling, as though I had once more been disturbed from gritty-eyed sleep.

We turned down into a steep, narrow lane with graffiti and more oil drums, when the car stopped. I thanked the man for the lift. As the car pulled away slowly, the old man continued to grin at me. As he raised his thin shaking hand, I recognised it as the hand that had given me the piece of paper in the churchyard.

The slimy water lapped at the dock side, creating flowing shadows over the looming, rotted walls behind me. As I paced up and down I stamped fragments of glass into tiny balls. Litter blew all around, flapping from yawning entrances of abandoned buildings and out of the rusted port holes of a few rickety boats. The smell of fish and old rubber had become rancid over the empty years, and now the stench was as noxious and corrupt as a charnel house.

I continued to pace up and down in the area between a solitary lamp and its dim reflection in one of the few extant windows. From this location I could see the road to the left, the tumbled-

down warehouses to the right, and the dark expanse beyond, in which the murky waters were obscured. I could also see my pale reflection in one of the broken windows: a wan countenance superimposed over the wreckage of debris and filth. It was from within my reflection, by an odd trick of the angles, that the barge appeared, at first as a glow on the horizon that I barely detected within the reflection of my left eye. As I stared in fascination, the ghostly light grew from my eye, spreading its way across my face, eventually blotting out the details of my features until the whole reflection incorporated an abstract, almost ghoulish, montage.

As the reflection continued to break apart, I let my attention concentrate on the image of the approaching barge. After a time, it grew larger than my head and filled the crazed window pane with billowing shadows, so that

at last I turned to see the object itself as it passed into the clutch of shadows at the dock side.

The barge docked with a rusty clanging noise that caused an undulation in the tarpaulin covering the deck. Squinting into the dimness, but staying carefully within the shadows, I saw a ghastly figure emerge from below deck and set about the task of untying the tarpaulin sheets. He was an old man with spare, sinewy limbs and long strands of unwashed, unkempt hair. His fingers were long and bony, crawling into the deep, billowing shadows and emerging with strands of rope. His face was partially obscured, but the texture of his skin appeared flaky — white and diseased — as though it were crumbling away. At last he heaved the heavy sheeting away, revealing a mound of putrescent corpses.

"Help me with these," he said, grinning.

I stood for a few minutes, expecting someone else to emerge onto the deck, but then I saw that he was looking directly at me. Despite my hiding place deep within the shadows, the old man could obviously see me clearly.

"Help me with 'em," he said again.

He had started to carry the bodies from the deck of the barge onto the dock side, as though his intention was to transfer the revolting cargo onto dry land to await collection. After a few moments, I climbed onto the boat and began to help unload.

It must have taken about an hour. It was delicate work, untangling all the entwined, soggy limbs, making sure one didn't just grab an arm or leg and indiscriminately separate it from the body. The stink was vile. In the darkness, I felt all sorts of little movements within the mound of bodies that indicated parasites at work, or the egression of previously trapped, noxious gases. After the task was completed, I sat in a stupor beside the rotting pile, studying the contorted faces until at last I looked up and noticed the barge had gone . . .

Hours passed; it seemed ages before I noticed the old man, skulking around in the shadows, searching for something in the abandoned drums. Every so often, I heard the loud squealing of rats as the result of some commotion in the darkness . . . before long, the old man emerged, clutching something to his chest, gore dripping down from his poxy face.

The darkness seemed to go on and on; though I felt that dawn would soon break, it never did. Instead I perceived, in place of the sun, another pale, ghostly glow on the horizon. I knew another vessel was on its way to pick up the ghastly cargo.

We spent another hour or so,

loading up. The old man motioned to me to stand back as he made the tarpaulin secure. Without a word, he untied the moorings and we floated away into complete darkness.

I think I must have been ill for many hours because when my consciousness re-emerged after a seemingly endless sleep, I found myself on the deck of the barge; everything was once again pitch black, and I could only imagine that I had slept through the daylight hours. The old man was seated in a worm-riddled chair, staring vacantly ahead and no matter how much I wanted to question him about the previous night's proceedings, I dare not disturb him. Neither dare I move away from my present position into the absolute, suffocating darkness beyond the centre of the deck. I slumped down miserably, hoping the journey would soon come to an end. But it didn't.

The barge moved sluggishly and hours drew out into what seemed like days, though day itself never came. Everything was shrouded in total darkness, and after an uncountable time it seemed to me that the old man, his hideous cargo and myself became the epicentre of an entire universe within some dreamer's inconsolable nightmare. I spent eternities in morbid, fruitless introspection, never daring to move even a few inches in any direction for fear of falling into the black abyss.

Finally, sleep must have taken me again. When I awoke I became immediately aware of something different, though the old man sat on, unmoving. At first it seemed to me as though there was a different sort of motion; a different kind of vibration which I could not explain. Then, I began to detect a dim glow at the perimeter of the darkness which grew slowly brighter as the barge sailed on. Soon I knew we had sailed into an underground river. The glow came from an encasement of phosphorescent cave walls which grew in stature as the darkness dissipated . . . and in the distance I could hear a booming sound, as though at some point the stagnant waters of the river lapped onto a dark, subterranean shore . . .

The rest of the journey passed in silent anticipation of the shore ahead; the booming sound of thick, black foam as it crashed onto some hidden embankment became louder and louder.

The patches of phosphorescence clung in intermittent segments of rock, so that our passage was accompanied by a slow motion stroboscopic effect of greenish light and thick darkness. I watched the alternation of shade play over the old man's wretched face, giving the effect of undulating movement where in fact there was none. He stared blankly ahead, motionless as one

of the mouldering bodies beneath the tarpaulin.

As the barge progressed, I began to notice what appeared to be ornate, man-made carvings on the phosphorescent walls, and for the first time I moved from my slouching position in order to examine them more closely. As I studied the carvings, I became confused, wondering if they were in fact artificial, or merely natural formations in the rock. Whatever the explanation, I had never seen anything so repellent in my life, and I despaired at the thought that the monstrous shapes might be no more than the product of my disturbed mind, creating horrors out of the suggestiveness of gnarled, twisted formations. I slumped back in utter confusion, deeply sickened . . .

I was in a benumbed state, on the very edge of unconsciousness, when I began to sense movement around me. Rousing myself, I saw the somnambulistic old man flapping at the tarpaulins. Suddenly the vessel came to a clanging halt. As my mind focused, I became aware again of the thunderous booming, though the waters all around were as black and calm as before. There was no foaming tide crashing onto a dark, slimy shore as I had imagined. The stench-filled river lapped disconsolately against a crumbling brick dock that stretched ahead massively into darkness.

There was no more time for wondering. The old man tied up onto the rusty moorings and immediately released the heavy sheet that covered the now crawling mound of infested corpses. One by one, as before, we unloaded the bodies onto the dock. I grew aware only of my task, gingerly taking hold of the moist, pulpy limbs, stacking the bodies into a mouldy, tattered skip that lay a little way along the dock, listening to the din of the booming sound in the distance.

The unloading took longer this time as the cargo had to be handled more carefully. When the ship was full, the old man motioned me to take one of the rusty chains that acted as a handle while he took another, and between us we began to transport the load to a location far out into the yawning darkness.

Our progress was slow and agonising, and with each step the thunderous booming sound grew louder. Eventually, as the roaring din grew intolerable, we came upon a vast open well in the crumbling floor. Without a word, the old man walked towards the precipice of the abyss and kneeled as if in awed supplication. The roaring from below was ear-splitting as I approached, hardly daring to put one foot before another in the darkness. At last I reached a position from which I could see . . .

There was a rising column of

vapour, the colour of which I have never seen before, a vaguely phosphorescent blackness, swirling and moving like the sea, but very turgid and thick. All around me the floor crumbled and cracked, and the air was charged with a static, suffocating vibration which made me scream, tears running down my aching face. As the old man moved toward the skip and took out the first body, I continued to scream my lungs out. I could not stop screaming. The old man mouthed the word HELP, and as I carried the bodies with him to fling into the black pit, I still could not stop myself screaming . . .

I only stopped when the last of the bodies was thrown to the thing in the pit and the old man slowly pointed his finger at me. I could just hear him as he bellowed above the thunderous noise . . .

"You . . . You now!" His fractured countenance was wracked with pain. "I have done, now."

He pointed his long, shaking fingers toward me one last time, grinning hideously. Then he flung himself into the pit, disappearing into the colourless vapour, dissolving into the vast crashing blackness beyond . . .

IT ALL HAPPENED a long time ago. I may have forgotten some parts, swallowed by the desolation of routine . . .

I can remember docking back at the harbour the first time, after what seemed like many months of subterranean voyaging, finding there a pile of rotting bodies I expected to see, sharing a few words with the grinning man in the back seat of the car. Since then it's all been completely uneventful. More and more of my memory fades and I have found myself thinking and moving as little as possible, filling my mind only with the noise and smell of the blackness, with the total blackness of the pit awaiting me . . .

Now I just sit and sit, having secured another load to the deck, untied the moorings, slipped out into the greasy lapping waters. Everything is utterly black. As black as pitch. But nothing can ever be as black as the final blackness that awaits me when this task is finished.

In The Arena

KELLER STARED out of the café window contemplating the rain. The early morning streets ran with muddy water. He looked at his hands, looked into his half-empty coffee cup. The strip light overhead buzzed on and off as thunder drummed in the sky. He looked at his watch — 7:35 A.M; it was time to move.

Keller turned his collar up, winced into the driving rain. He could hardly see the cars in the darkness. He tried to detect their presence sonically, moving blindly as if by some cryptic subconscious volition. Nervous, thought Keller; but why? — You've done this sort of thing so often before . . .

Last night he had been unable to sleep. He kept turning the note over in his mind, reading the words like hypnogogic pictures:

the tall, fair-haired gentleman

— the note said —

3A, Johnstone Place, across from Micksgrill café . . .

The pictures flared up in his mind, painted inside his eyelids. He could even see the fair-haired man, very clearly, *vividly*, though he was sure he had never met him before.

At a junction where the morning rush hour traffic thickened, Keller realised unhappily that he had headed away from the house again. That made it three times in a row, after three cups of terrible coffee on an inordinately nervous stomach. Hadn't he got up so early to get it over with? Resolutely, he headed back to Micksgrill. As the morning stretched out, the rain and darkness gathered.

9:15. Keller ran his hands down his wet face, wiping away

67

the clinging, muddy rain. His face was illuminated intermittently by flashes of intense lightning. It seemed to him that, at last, one particular flash had galvanised him into life. Without realising it, he had set off across the street and now he was before the tilted portal of the house.

Keller peered intently at the shiny black numerals and then pulled gently at the door. It was open. He slipped inside, dripping moisture onto the stuffy carpet.

The ceilings were high in each room. Columns of dust were etched in the pale light against the window. Each room was alike in atmosphere and decor. Keller scanned over the crumbling edifices of old fireplaces nervously; he measured each shadow for sudden movement. Thoughts raced through his mind: why did he feel so nervous? Perhaps the Others had set him up! Maybe this was a trap . . . but why would the Others want to get rid of him? — he didn't know their identities; he had never see them — and he had always succeeded in his tasks, asking no questions, receiving the usual large sum of money gratefully . . .

As Keller mused worriedly, he began to wonder if the house was abandoned. Certainly, there was no sign of habitation: everything was decayed and covered in dust. As he emerged into the stairwell he noticed that part of the staircase had caved in. He climbed pre-cariously in the silence to the upper floors — and yet, when he stopped to get his breath, he thought he could detect someone moving about very carefully in one of the rooms above. He wiped his hands on his trousers where they had been shielded from the rain by his overcoat. He drew a revolver from inside his shirt, wiping the thin barrel carefully with his shirt tail.

There was no one in the first room, but it looked to Keller as though the dust and the rickety floorboards had been disturbed. He poked his head carefully around the next door. In here! He knew it.

In the enfolding darkness of the room, he could see a bed covered with splayed papers, a few books tossed incoherently on the stained floral mattress. On the wall over the bed was a curious design, like a monograph; strange arabesque twistings suggested a leering face. Eyes opening. At that moment someone moved. Keller saw the billowing outline of a tall figure behind a torn, hessian partition. Without warning he fired, three times in rapid succession. There was a creaking noise. Keller suddenly screamed out, dropping the gun. He slumped to the floor holding his hand. It felt as though it was on fire. In startled confusion, Keller wondered why his hand was bleeding. A cold pain came into his head, but almost at once

it withdrew. Emerging into the pain, coming and going just as swiftly, was the vivid picture of

the tall, fair-haired gentleman.

Keller slumped against the wall, unsure whether his victim was dead. The Hessian now seemed alive with flies. He closed his eyes, pushing at the utter confusion in his mind with all his willpower. Then, the fly-covered partition fluttered slightly, as if in a cool breeze. Keller held his left hand against the mutilated fingers of his right, pinching the bloodied flesh together. The revolver lay in a pool of blood on his lap. With mounting desperation, he saw the flimsy partition bend toward him, loosening the flies momentarily. He flung himself down, wincing, reaching for the gun. The other man lunged through, making a long screaming tear in the rotten fabric as he fell to the floor.

Keller heaved a rattling sigh of relief.

He stared at the trickle of blood that emerged from his victim's left ear until he passed out.

KELLER WAS staring into a dark empty space. He couldn't remember where he was. Then, the pain in his hand reminded him. He sat up slowly. He looked at his damaged hand for a long time. His little finger was almost missing; the middle finger looked

chewed up, clots of blood like raw tenderised steak. Carefully, taking his time, Keller tore his shirt tail into strips and bound his hand up tightly. While he was doing this he saw that the Others had left him another note. In the dimness, he could just make out the laconic statement:

Consider yourself promoted. Life certainly is a hard test. You passed this part. Get rid of the body. Do it now.

Keller folded the note up carefully. He was angry. Why had the Others left him here when they could see he was in need of medical attention?

. . . Get rid of the body. Do it now.

The man was slumped over awkwardly. Keller pulled at his blood streaked arm. Already it felt stiff, so stiff Keller thought it was about to snap. He threw the corpse with grim effort on to the bed. The weird design fell off the wall making Keller jump as it fluttered down like a huge moth. It landed on the man's torso. Keller watched it slowly soaking up blood.

Why was there so much blood? With the heavy curtains parted slightly Keller could see his victim's body more clearly. It looked as though parts of it had been passed through a grinder. Strips of flayed flesh lay in horizontal

stripes across the torso and arms. A rib poked out sideways like a broken stick.

Keller stared in amazement. Nausea seemed to flood through him. He almost laughed as the legs suddenly parted from the torso like ripped polythene.

Keller looked at his watch — 17:10. The dismembered parts of his victim lay on the bed, wrapped securely in wide strips of hessian. It was now getting dark outside. Keller decided to move, finding a back way out of the house, dragging the grotesque parcel over his painful and bloodied shoulders.

The night was pleasantly windy. The rain had stopped. Keller laboured over the muddy flats of abandoned allotments. Every so often, he untied the bundle and threw a piece of indistinguishable flesh into the night sky. Dog meat, he thought; consider yourself promoted. He was sickened to the pit of his stomach, but the thick wad of bank notes he had found in his coat pocket a few moments earlier made it all seem worthwhile, despite the terrible effort and nagging pain of his lacerated hand. Retying the bloody parcel, Keller stumbled to his feet again, mud spraying everywhere. He had no idea where he was going.

Before long he found himself in utter darkness. The air smelled fresh and clean. In the distance, he could see the lights of the city illuminating a gigantic depression of bruised-looking clouds. He smiled grimly to himself. Just then, the grey light of the moon broke through, as if the darkness had given birth. It illuminated the field, wet with swaying grass, smelling very green. He flared his nostrils taking in the sweet perfume, listening to the distant rustling of trees. Then the smell seemed to change. The sweetness was replaced by something even *sweeter*; something rotting. Keller stared down at his feet. The mud seemed to be churning with shreds of putrescent flesh. He retched but was unable to produce the vomit he had expected. All that had come out in the house. Nothing left, he thought clinically. He slung the shapeless hessian into the mud.

Time passed. Keller wandered through the darkness as if motivated by something. He felt now that he was searching, but he didn't know what for. He headed for a coppice of gnarled trees, sectioned off from the seemingly never-ending acres of field by a muddy track.

The trees seemed to whisper in the breeze. He splashed over the track and into their embrace. All at once, he felt as though his skin were crawling, then the sensation passed and a leadenness replaced it; an inert numbness. Keller stood like a statue of dead flesh within the circle of trees. With careful observation, he saw what appeared to be human fingers

hanging stiff and white from the webbing of twigs. Dark blood, almost black, pulsed down the trunks and nurtured the white, grub-like roots. Keller turned bodily, swivelling. The trees on the other side were made of a pliable white substance that pulsated. Keller was reminded of his victim's intestines. He let the simile flow through him without effect. Without effort, his body swung again. All around him the trees were rattling with brittle flesh. He blacked out.

When he regained consciousness, he was walking very slowly. There were figures in the darkness, seated around a table. Their faces were covered by cowls of dust; indistinguishable. They did not move. Keller felt only dimly aware of himself as he peered at a new note which had been slipped between his fingers, which read:

You are here now in the arena.

Keller stumbled in the darkness. He emerged from the unlit chamber into an outer darkness that seemed unfathomable. All around him there was hideous movement. He walked without moving, deeper into the circle. There was no air, only dark corrupted wind. After a few seconds, the movement seemed to crawl toward a common centre where it formed into a face; the face of

the tall fair-haired gentleman.

Something was alive behind the corpse's dead skin as it spoke, not the intelligent animation of real life, but something moving that wore the skin of a dead man to create a semblance of life. Somewhere in the distance of his being, Keller convulsed.

"In the arena," the dead thing said, "very good . . . you passed . . . prosaic, old fashioned, perhaps . . . I know you have lost your soul to me . . ."

The picture of the monograph over the bed flashed into Keller's dim mind like a bolt of lightning. In the light of the hessian screen, in the flash of pain, Keller saw his victim turn into an animal biting down on his gun hand as the shots peeled out . . . shreds of flesh . . . trees squirming in rotting darkness . . .

"The Others . . . the Others wait for you," said the face, "one last note . . . big promotion . . ."

The dead thing that had once been Keller did not know how long it had been sitting at the table when the Others admitted it into the mind behind their dead faces. It was dimly aware of the fair-haired gentleman, writing notes to someone else. It found itself contributing with the Others to the shape of this other man's thoughts and dreams.

In the dust and in the silence something in the outer darkness waited for the last place at the table to be filled.

The Exquisite Corpse of a Multiple Personality

AN UNPUBLISHED MS. found among the possessions of the late Dr. H. S. Meyer of the Institute of Psychiatric Research, Zurich, Switzerland. Dr. Meyer's Note:

The technique known as 'the Exquisite Corpse' will be familiar to those students of the Arts who have followed the more obscure currents in the backwaters of our burgeoning culture. As a way of allowing numerous artistic collaborators to express the fundamental unity of the creative unconscious mind — be it in the form of a poem, a story or a piece of artwork — the Exquisite Corpse, as a composite object, displays a surprising coherence which seems to tap directly into the chaotic stream of images from dream and myth.

The MS. presented here investigates the same territory as that which preoccupied the French surrealists, but it was not written by a group of artists; it is the work of one man only: an extreme schizophrenic, sufferer of multiple personality complex, whom I was lucky enough to interview several times during the course of my residence at the Institute.

The individual in question (who shall remain nameless) presented the following MS. to me several months ago as evidence (as he put it) of the completion of an experiment in which the various components of his fractured personality finally came together. The result is the 'Exquisite Corpse' which you are about to read; something so horrible and grotesque in appearance that its very image reveals the intangible thread connecting dream to reality.

—H. S. Meyer, November 28, 1936

72

1

I AM ALWAYS awake on the black slates. My hair floats like rain water from the roof; how does it hold up here under the weight of the violent windstorm, represented symbolically by a rough, brick-walled cell with bars at the tiny window letting in the moon. . .?

I am aware of the roots crawling up my body from the lowest level. And when I say 'lowest', I do not mean 'lowest down'; I mean 'vile'.

Someone pushes food under the door. I have to eat the food before the beetle-collector emerges from the earth beneath my feet, shaking himself free of my soiled hair and losing his way in the cold place at my forehead.

How long have I been here? Trapped with corpses sleeping on the slimy tiles, huddled into their foulness to escape the rain, the rain. One of them has a mouth like a mirror and inside it I am a little boy at the dentist's, spitting out my teeth. In another play, I am the dentist: spitting at the friends who have betrayed him; sitting by his wife's grave in silence; buttering bread to the sound of a great, ticking clock. The audience jeers and makes a raucous roar of mouths opening wider, wider — "Say 'Ah'!" — laughing all their teeth from their wizened faces on the cold head of the rolling roof. . . like hair, dark with slime and soil. . . the hair of companion corpses. . .

2

I USED TO be an undertaker in the mortuary. I still look at my best black suit in the morning, when it is light enough to see in here.

Look at my bloody hands! It's a good job I am not working anymore; it's a disgrace. Look at all the dead hair in here — enough to stuff a pillow, except that it's all entwined with big black beetles that would eat their way out of the pillows and go down your ears and into the bed. Like that old woman we had once, poor old cow, full of worms (or was it maggots?); black coiled-up slugs like over-ripe rinds. Beetles on the cold stones. . . good job there's not a hot plate in here for them to blunder on to, or they'd be cracking like chestnuts. Reminds me of a joke the old man at the library told me. A queer, creepy old fellow. . . he has passed on now as well. I found his pockets full of ancient thumbnails, fossilised and thick as the coating of ammonites. I couldn't remove the silly grin from his face — I make the same

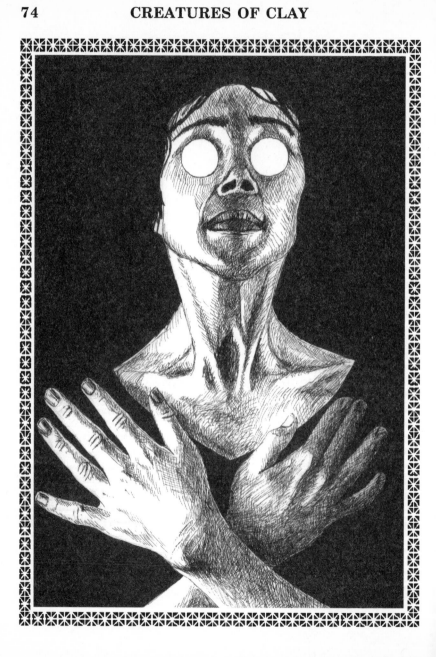

silly bloody grin, here in the mirror. Could that have been a steep roof, reflected, I wonder? But I know it is only the slope of my black hat — my jet black hair, I mean. . .

3

I CAN SEE myself in a dream, sliding down a roof like the one in the reflection. . . a little white-haired girl, legs poking straight out toward the tufts of insects in the slimy gutter. . . grass awry in the lowlands, leaning like tombstones. . . passionate little mouth. I am crying as I slide down the roof, shooting on an invisible toboggan on to the wet tiles. . . and suddenly I am driving a big black car into a shape in the middle of the road. I try to slam on the brakes, seeing the boy's shadow merge into the front of the car, when it begins to disappear, to merge with the boy, passing through him into the black rippling depths of his shadow (another road death, another corpse to be laid out by my trembling hands!). . . only to find myself staring at the ceiling as the beetles make their way toward my head, inside my frigid body. . .

4

THE BEETLE-COLLECTOR. What an interesting hobby, to stare up into the empty roofs of the big world, scratching my cold black legs, which are covered with a thick liquid, like furniture polish. This is the only way to live in here (he points a long finger to his skull). . . the only place to live when you're a beetle-collector. . . a corpse that moves, animated by an invading life-force, like a beetle-clock! Ticking with hard, shell-like wings, flying over the sloping roofs, wet hair tossing spray into the teeming guttering, between the gnarled elements of the brick wall that keeps it all in, trapped like a genii. . .

NOTE: Here the MS breaks off abruptly, though there is an accompanying illustration, folded into four concertinaed segments, depicting an almost abstract figure of black slate. The head is an angular nest of curly black hair, with teeth in which beetles crawl; the torso is a granite coffin, split open at the seams with emerging insect life; the genitalia is that of a small girl, lacerated by cuts and embedded with slivers of glass and metal; the legs are the six legs of a giant beetle, positioned precariously on a wet roof-top gutter. Underneath the drawing, the inscription: "my head above Heaven; my feet below Hell."

The Little Death

THE DOCTOR had prescrbed antibiotics for my illness. That was when I first saw the house.

I have never been sure whether or not I had the experience due to a reaction to the penicillin. Certainly, my fever grew as the night wore on. It started with the creaking of floorboards. The last thing I can remember is staring at the clock as the digits flashed a red 8:01: then, it was as if the commonplace scenery of the room melted, slowly. While I was aware of my body, my mind felt somehow sharper in a different way, though I remember vaguely associating the creaking of the floorboards with the tumble of my body as it twisted fitfully on the bed. I passed into an area of darkness and the association crept out of concern's way.

At first I thought the structure that towered above me was a ship. Wooden beams creaked and heaved as though tossed by waves. Then I saw trees along the steep incline, and as the black clouds parted I saw the reflection of a curious green satellite in the windows.

I have never seen such a dingy-looking plot of land. The garden, such as it remotely resembled, was a jungle of twisted roots and vivid yellow weeds that emitted a nauseating stench as I brushed past, eyes fixed on the vast wooden house. The climb

was hard and sticky. Several times I slipped in the clayey soil, repulsed by its texture, like pulpy flesh; a thin film of soggy skin holding it all together.

Finally, I fell under the shadow of the house — standing peering up at its twisted frame; the smell of wet wood and accumulated dust. As I stood in the silence, my attention was caught by the impenetrable tangle of thick, ropey roots underneath the boardwalk of the porch; as though the house had not been constructed as such, but had grown there out of the chaos of gnarled limbs.

I STOOD before the door for a long time, like the house, rooted to the spot, while the dark sky tumbled overhead, soundlessly. Then, there was a faint smell of antiseptic ointment. I awoke feeling bright and clear-headed. The digit of the clock still read 8:01.

THE NEXT DAY, feeling much better after disposing of the suspect capsules, I tried constantly to figure the incident out. The dream itself was much more than just a dream, of that I was convinced. Though it had obviously only lasted a fragment of a moment, the experience seemed to go on for hours. Finally, I decided the best policy was to forget the whole thing. I put it down, logically, to a product of fever. Yet, that night the dream continued.

THIS TIME, without the attendant fever and anguish, I found myself before the door of the house. I was standing on the porch and a curious thrilling sensation seemed to pass through me, making me begin to feel sexually aroused, and at the same time, almost fearful. With a tentative step I opened the door.

My eyes met a dim chamber that looked half like the middle of an old tree. The walls were moist and warm. The whole structure emitted a phosphorescent green glow. As I looked around, puzzled further by the pleasant vibration around my genitals, I saw a huge staircase as the hallway opened out.

At first the steps seemed encased in a colossal spider's web, but on closer inspection the strands were coils of wispy roots breaking though the boards. In several areas the steps had turned into bent limbs, like the broken fingers of branches on a lightning-struck tree. There was a constant sound of dripping liquid, too heavy for water; perhaps it was sap trickling between the walls.

After peering around for a while, I began to scale the stairs. Each step was spongy, and my effort in treading upward in-

creased the vibration coursing through me until finally I had to stop midway up. . . without warning there was a rush of bliss. . . I had to steady myself, resting my hands on the decaying banister as the ejaculation took my breath.

ON THE FOLLOWING day, my sexual excitement drove me to distraction. I felt cruel with lust.

I'm sure the effect, had it not been so startling, would have seemed comical. I had always been more than interested in women, but after my first marriage broke up, I confess to feeling the typical male misogyny, with attendant fantasies of punishments metered out in repayment. It had occurred to me how similar the stories in spanking magazines were to horror stories; the "poetic justice" of the denouement, the shock ending and the inevitability of it all.

However, at the time in question, I hadn't the inclination to analyse it all. I made images of torture and punishment my icons, safely encased in my room without the stress and disappointment encountered in the outside world. And at night, the dreams — the hallucinations — continued.

After days had passed, I made a concerted effort to ignore my constant arousal. I bought a book on the subject of so-called "astral projection" to see if this would explain my dream of the house. It did not.

My obsessional behaviour became increasingly morbid. Despite a certain distrust, I decided to see my doctor again to see if he would prescribe some sleeping pills. He was very interested in my case, though I revealed little at first, until he mentioned "the little death". I wondered if I had heard him right. . .

"LA PETIT MORTE: the little death, is the orgasm. You are suffering from the need to relieve your sexual tension all the time. . . am I correct?"

I was astounded.

"The term is algolagnia. A more recognisable label is sadism, I expect. But algolagnia makes a more, ah, special connection between pain. . . and death, and sex. Do your fantasies take the form of ceaseless and constant punishments?"

This was all too much: "what were those capsules you gave me last time?" I asked.

The doctor smiled.

"I told you, antibiotics. . . and now you require something to help you sleep."

I SHOULDN'T have taken the pills. That night, as I lay in bed, I felt myself becoming unfocused, fixed into the creaking house by a miasmic apathy brought on by the drug. Night after night I had

attempted to make my way up the stairs, only to be stopped by an almost unbearable orgasmic force coursing through my entire being and rooting me to the spot. I felt I had been growing into the house; being absorbed by its addictive vibration.

Now I walked almost without feeling. Each step beyond the point I had previously reached was an orgasm in itself — yet I was detached; remote. I soon found myself in another wide corridor. Here the knots in the boards and the walls resembled grimacing faces, turning and twisting as the strange energy pulsed in me. I remember thinking that were it not for the sleeping pills, I could not have reached this point. My ears strained, needing to pop to relieve the steadily escalating pressure.

Then I saw a door.

I was in a room. It was pulsing and humming with latent life, a web of dark colours in greens and soft, furry greys. At last my stupor passed away and the drumming in my ears abated.

I realised I was sticky with semen. My loins felt inflamed, and in agonising bewilderment, I felt myself stirring again.

On a cold, mossy table lay a book. Paradoxically, its shape seemed at first alien to me: the crisp, white paper, the bright colours.

Each page had a drawing calculated to drive any misogynist to distraction. A beautiful, soft, vulnerable girl receiving canings, strappings, spankings .. over chairs, tables; over hard male knees — the gloating looks and the obvious excitement were etched perfectly on each tormentor's face. A sheer, gut-wrenching bliss of torture, page after page. My tumescent penis twitched and ejaculated time after time, with its own life, like a bloated insect disgorging poison. I continued turning the pages, feeling I had finally reached some secure, indulgent heaven.

Then I noticed the trend in the pictures begin to change. Not only were the male faces growing more and more bestial, they were becoming somehow. . . alien. . . their shapes changed from one picture to the next, emphasising not only a different sex, but a different species.

Finally I came upon a picture entitled: "The Little Death". Even though my passion had begun to change, I was not ready for this mutation. . . this sudden shift. I became revulsed with myself. In this picture, the torture became extreme — blood and real fear replaced what I had seen before; no more coy tears on the girl's face, only sick agony and a dreadful expression of deathlike exhaustion. Still, the male assailant, now totally altered out of recognition apart from his obvious and transcendent excitation, pierced and beat the girl mercilessly. . .

I PLACED the book down; unable to stand, I crawled and lay back against the soft, green wall, still twitching with sexual convulsions.

I DON'T KNOW how many days passed. I was still in the house. After a long time, the doctor came to see me.

"How did you get in here?" I asked.

"Oh, I've known about this place for a long time," his insect-like voice said, "I like it here, but unlike you, I can come and go as I please."

He wasn't gloating, I was pleased to observe.

"You've given yourself a nasty infection there," he nodded down at my crotch, "can't stop playing with yourself. . ."

Through the dim window the roots of the house seem to stretch all the way to the strange green moon. Here I sit, feeling with each orgasm my roots growing into the house, the house roots growing into me, and really I don't care anymore. I passed through a stage of disgust for myself, as we all do. Now I feel things the way the soul of the house feels things. Little bursts of energy feed me constantly.

I can see the pictures I truly want to see.

Each one is, to me, a little death.

The Music Room

THE ROOM in which I walk is like a vast, dark, open plain. In my mind's eye, the piano stands beneath the vaulted columns of drapery, yet I cannot see it clearly, despite the endless row of mirrors — or are they in fact windows?

My hands seem to rub themselves together of their own accord, though I am not cold or particularly anxious. It is just that otherwise they would seem so lifeless, like the hands of a mummy. It is interesting to view them now, in this place, as being somehow separate from the rest of me. The signals from my brain to my hands are muffled and indistinct — the equivalent of the sound of a slowly dripping tap in some other room, remote within this vast house.

This incomplete meditation has brought me before the darkened panes, which I see are obviously windows, though they reflect more than they should. I stand very still before them, studying the subtlety of their architecture. They seem to be so delicately structured that they belie the wind and rain outside, relegating these elements to vague and indistinct impressions. I dare not release my renegade hands from their independent thrall, for fear that they might touch the cold, black glass and shatter it, releasing alien atoms

into the room.

Now I am wandering along the inner perimeter of the windows, listening intently to their quietest sighs, their most insignificant rattlings, as though qualifying and defining my emotions by their abstract signals — keeping at bay some dim memory that threatens to engulf me. Is it necessarily a memory of something in the past? Need it be a memory from my past, in particular? I shudder, clamping my eyes shut tightly, hearing the creaking of my skull, realising that it is, in fact, the creaking of the piano stool. I open my rheumy eyes, expecting to find the room empty, the figure at the piano vanished — but this is not a ghostly visitation, and I see my dear wife's face smiling up at me from above the glistening keyboard.

She begins to play. The cadence of the music is strange; the tune seems common enough, but I cannot place it. My wife plays on, her own entranced hands mimicking mine, their twitching ciphers translated into notes and chords played by other hands, perhaps in this room many years from now — perhaps in this room many centuries before this mo-

ment. I cannot be certain.

I begin to back away from the piano. All at once it stretches away from me, as though I might be viewing it from the wrong end of an old, dusty telescope. The figure of my wife — her closed eyelids, her blank, enraptured face — shrinks into finality, her music replaced by the sound of my breathing, heavy within some confined space.

The universe seems to have blinked out. I am aware only of my entrapment within the folds of the heavy curtains, the icy glass of the window pressing into the small of my back, into my splayed shoulder blades. Am I screaming? I seem to go up, up. The dust enfolds me. The thick, cloying drapes sink into my face like a death mask, and I am forced to turn my head toward the window, where I can see myself screaming and screaming, my dark, open mouth emitting a curious, whining vibration against the glass.

When I emerge moments later, I find my dead hands rubbing themselves together of their own accord; I find the room in which I walk — vast and dark — going on forever.

The Crawling Seed

I WAS IN New York City Scum Capital of the World. In some unidentified slum area; I'd been told to wait outside the NEEDLE LIQUOR STORE. The fat taxi driver had tenuously identified it for me as being somewhere between 4th and 5th. I had to meet a man called Denzel. I was nervous.

Some black men stopped in a car. I thought they were going to rob the store, but one of them got out and said my name. Raised his eyebrows at me.

"Denzel?" I confirmed. He nodded: "Follow me."

What if I get ripped off and beaten-up? — I was thinking. What if? What if? Then we were there. I'd expected a long walk.

"You go up and you ring the bell and ask for Candy say Denzel sent you. . ."

He held his hand out for the money.

I counted $100 in tens out to him while he looked at me wondering just how much money I'd actually got.

I went up the stairs. Just like in one of those sordid films about New York street life. Grim, bare walls. The usual graffiti. Piss smell. People arguing behind reinforced cardboard walls. . .

I pressed the bell, said: "Denzel; Candy?"

The door opened and I went in. The room surprised me. Quite

spacious, And clean. I cheered up a bit. Candy wasn't a black girl. She was white. Very white. Natural blonde hair. Without asking, she poured me a drink and brought it over to me. She even smiled a bit. I was so nervous I nearly spilt the whiskey and soda. I tried to sound O.K: "Let's get to it," I said.

She pulled off a jumper, getting stripped in no time, soon laying back on the bed, her legs open. This did nothing for me and she could tell so she smiled again — said something — put her arms round my neck — rubbed her legs against me — her breasts. . .

ON THE BED I was thinking this was fair enough but I expected her to be dry between the legs as per. — but she wasn't: she was wet and warm and when she licked her lips she looked nice. She looked like she really wanted it.

My cock started hardening and I gained some confidence because I knew I could get it up now. I pushed my cock into her and it slid in very easily. She was really wet. We were fucking.

It went on like that. But not for long. Though my cock seemed big and hard I felt like I was losing my erection again. And then she started with the coughing. Gently coughing. Against my ear. I said: "Can't you stop that?"

"Sorry. . ." cough-cough-cough. Every time she coughed she got wetter and wetter; she was drenching me through. I didn't know whether to be complimented, or not. (Ha Ha — Joke).

"Look wait a bit", I said, "Relax, and stop coughing."

She moaned. Long and drawn out. More coughing.

"Oh fucking hell." I pulled out. My cock was red raw. Stinging. I felt dizzy.

Candy stared up looking stupid straight up at the ceiling.

"What the fucking hell've you got? oh god" — it was like somebody had put paint-stripper on me. It was making me mad. The way she just stared up stupidly. I started calling her a cunt and shouting at her. Nothing. Except for more of the stuff leaking out of her.

"Bitch! Bitch!" Nothing. No response.

I gave her a sharp punch in the pelvis and her bones just gave way. She just caved-in: oozing slime.

I jumped off the bed. Fell. Dizzy. Blackness spiralling away. I seemed to leave my body behind. I seemed to float about.

I saw Candy try to get up from the bed. She looked undisturbed. Moving about. Trying to potter about with stuff. File her nails, comb her hair, look at her eyes

in a hand mirror.

With my new eyes I could see her seed on the bed seeming to crawl back into her. Phosphorescent. Stinking. Alive. . .

I saw her bones reform. She stopped twitching. Something lit up outside the window. She turned round to look, moving quite gracefully.

I went back into myself. But I couldn't see.

I was shouting out: "I can't see! I can't see."

There was just my head.

Candy put it into a box. She shut the lid. And then the head began to slowly revolve inside. Like the first stirrings of a dark planet.

The New Continent

HIS WINGS are as sharp as alien metal, half-formed like mist over his bloodied black eyes; teeth scoring sores and blisters, drawing small, drab mosaics of blood as he flies into the sky, remote; dreaming.

Islands form in the clouds, sounds crashing from the waves of blue, yellow over the rim of the earth like mould straining into space. Waves glinting.

The moon floods over the sky, spilled like grey milk, forming islands and battlements and tombs within his struggling psyche. Orange colours, tinted with ochre shade, solidify into a continent; tired and sluggish, the denser elements crawl from his black tomb.

In the centre of his colours, his female lies, grinding her ornate thighs, forming a sticky river. She gives birth to squat, leathery little men, horned and blind, rearing up like the wind and crashing down like the sea.

He falls to this new earth like a grotesque owl, blood pumping vermilion shadows through his hollow arteries. His heart flutters like an engorged mantis.

The Female raises up from reverie; blood clots like huge rubies fall from her heaving centre. He puts his fingers in the pool she forms and tastes the essence; she moves, circling him, down on her hands and knees, her head level

with his own.

Mist issues from a crack in the sky, bending new shapes into being. Her eyes milk over, pupilless, as though blind. The leathery demons form into a procession; mourning him, lifting him by his great black wings, entombed in mist and silence

Somewhere a bell is ringing a dull, iron monotone, signalling the beginning of their dark wedding. . . But his flesh tears from spirit, leaving a gash of raw energy boiling in the earth, now grown old.

The stars are points of light in a hushed vault, reanimating his deadened eyes. Figures curl and blacken like wax and paper within his blood red flames.

The continent recedes into distant memory, where he flies once more in dream, white and cold; hungering.

The Cult of the Obscene Deity

OUT OF THE space-fields of dead aeons, centuries roll by in the blinking of a sleeping eye, jets of sperm coagulate, solidify, begin spinning in a set, remote orbit around the dark tentacular shifting of the void. In the grid of interposed patterns, a flood of light is interpreted as the sudden instance of thought flashing between pylons of brooding darkness; the brow-folding sleep contortions of the child God . . .

Blacker than any notion to cross the face of a swarming planet, ice-fields of vain ideologies like mindlessly gigantic cliffs surmounting a pin point droplet of water. From the fecundated flower, dizzy with sap-trickles, the mouth of the void breathes from the Other Side in billowing stillness — thought regained . . . regained from the monotony of blundering into the orbits of millions of stars. The vast knowledge in a sentence spoken by a million insectivore mouth, all sweeping like a dark plague of sheer Intellect from a tiny frozen planet at the space-horizon's rim. The nostalgia of the death-sentence: I HAVE RETURNED . . .

"I have returned from the bleak shores of space-hells where the boundless continents of nothingness lap straight into pullulations of solar fire. The white heat of transference, unbounded by cusps of fragmenting,

radiating darkness; the soul of the bore-tunnels into dimensions . . . I love the worlds so much I eat them like little delicacies, anti-strophic incisors biting the shrieking frosts of moons plunged into the oceans, ringing like a colossal bell across the watchtowers of space. I am the anvil that supplies the spark, that sparks the conflagration that heralds the configuration in swarms of stars. I am the trickle of darkness at the offset of Time. I am the first and the last and I am every stage in-between. From the unplumbed depths of cosmic night I come crawling like the ants that have hollowed out a skull, making the severed head, their planet's interior, free of brain, free of hindrance. I come crawling from the green web of the stars, from the dark pinions that line Arachne with pearl-like eggs, stars caught in Ariadne's net of hair. I am the skeleton pounding at the doors of death, the flesh falling from my bones, pleading for entrance into the citadel where vultures will strip me clean. I am the guilty hand emerging from the quicksand, I am the secret Hand of Glory, the star-venom of Lucifer, the Trident of the comet-god . . .

The Victim of Azathoth

THE NIGHTMARE will never cease. For the longest time, to be enveloped by such endless blackness, the suffocating spider-fear, the sewers of the known world's voids, this life like a postulant blister ready to burst, but never bursting, only memories, but they too are being forgotten, being held down, drowning in the mud-puddle of an oozing brain.

My identity, the smallest awareness of self, is shrinking, diminishing, the saltpetre of the soul, a death tsantsa of incoherent mumblings, through miserable stupid streets, through the death-houses, filthy little voodoo doorways of infinite dusty insignificance.

Am I a corpse?, a leper?, a foundling? Never to be found; is it my fate to dimly experience the outlines of my body crumbling, pouring out into the dark dust void? What sort of satanic foetus am I?, where are the other children?

The nightmare is ceaseless, suffocating in the infinite dust, body crumbling spider fear, only memories glistening like insect eggs in the web of horror, a puffball blister about to burst its filthy memories, dimly experienced, chaotic identities from the soul's sewer. Yet I must be aware, gaining consciousness, because I'm scratching myself again — a memory? — false? —

where the blood was dried, and I'm trying to sing, oozing in tune, a dark dusty tunnel opening like an awareness of rusted metal as a darker shape, almost a taste, against the black mephitic cosmos. Something like a bee buzzing — probably the gummy web spiralling out of its maker like dung-candy — popping in my ears, the realisation of consciousness emerging like a liquid to be vomited, bursting from a mouth like a blister, and with its coming: sound. Not just the sound of the web being spun, but real sound, in 4D, like a jewel from the middle of a black hole.

"So; here you are, I've been looking for you, I don't suppose you're feeling any better for laying down there in the filth. It's been thundering. You're wet through, it's stopped raining now, I've just looked at my watch, it's stopped, it's late, the moon's high, I feel sick too, and I feel hot, it's so hot, where did the girl go? Have you seen her since you fell ill, or have you been here all the time?"

The bridge is broken and I'm on the side where there are no materials on this small island to rebuild it.

"What are you talking about? The girl? The girl? Are you joking?, I haven't seen the girl for years, not for twenty years or more, not since we were little kids, its not my fault, I couldn't love her, not like I could love — him — that overlord. It's not me, you're thinking of someone else I'm sure. That's it, now, now I'm getting it, a flash, an image, don't shudder, its thundering again, that's all. I'm getting an image of an interior, a room, pale orange, the overall effect, em, aha, ha ha ha, peachy, pale orange, creamy — is this where — whoa!, that was a crash, that one was loud, it must be directly overhead. Why doesn't it rain, you said it rained, I'm not so wet, why didn't it rain properly? Why doesn't it flash with lightning? I don't think I know any girls! I'm sorry, Christ, God, not for years and years and years. But the room, the interior, what about the rest of it? — the bedrooms, bathrooms, kitchen, attic, no, no, nothing else. Only that one room. Pale orange. That's it now. An image, an overall effect I could love, a flash. A watch face, but as you so rightly said, time has stopped! Time has stopped! Stop screaming and screaming like that. I don't know if I'm supposed to scream as well, you imbecile! Should I scream as well? What should I scream? How about 'where's the girl?' 'the girl?' 'Where's the girl?' 'Where's the girl?'"

Am I a corpse? I'm alone. All the time I was walking without

realising I was even moving. Lonely voices as lonely and hollow as trees.

NOT ORANGE enough to hurt my eyes, more the colour of peach flesh, the room where I sit has a floor of glass that allows a view of the pits below. In my shocking state, in my state of shock, I can't believe I climbed out of one of them, passing the men with spiders eyes, mottled, bruised flesh like the underside of a dead dog. I hope I'm not staining the pastel shades of the room as I look below into the shifting blackness, tracing the history of my states of consciousness, silent as a toad in the baffled stillness, the watch on the table has stopped. There I am, like someone else, reaching for it, twisting the winder, hearing the fragile clicking mechanism as the watch starts ticking. Do I put it on my wrist?, do I go?, or do I put it on the table pretending it's not mine? In Hell's waiting room.

"WAKE UP! Wake up! You wanted me to wake you up, you didn't want to sleep all day again, you're meeting the girl. By the bridge. God, are you awake? Near the island. Don't look stupid, why are you baffled?, near the traffic island, what's wrong has your watch stopped?, don't look surprised, it's well past eight, your watch must have stopped. It's been raining. Do you feel any better? Don't be alarmed, that was thunder, its slowing down, its hot and clammy, the rain's slowing down, oh it's stopped, its stopped, you can see all the drops of rain on the webs in the garden, sparkling, how long will that last though?, not long you can bet. I'm going outside now, you'd better get up. It's images like these that rule our secret selves, our secret lives, and they only serve to tell us that we can only really see them when we understand we are never truly forever alone."

Washed; toilet; dressed; cup of tea. In Hell's waiting room. Through stupid streets, miserable tunnels through the dead dust.

"Alright! Stop screaming, and screaming like that. Stop staring at me expecting something from me. I'm ready to go, I'm ready to go, Lord! I can remember now. Remember perfectly well! And I can remember the pit, and the hollowness of the world. And I can remember *you* before you had any particular face."

Beneath the Black Obelisk

I WALKED through a field of tall weeds at twilight, pungent yellow blooms like giant dandelions, sap squeezing out into the marshy ground.

There was an atmosphere of expectancy, although I was completely alone; only the vague ghosts of those who had passed before me communicating some vibrant message which dwindled over the passing aeons; only the susurration of night voices which spoke through seashells pressed to the inner-ear of the mind.

I came to higher ground, hard-baked by the black sun which wheeled overhead like a smudge of soot. Against the darkness, registering on the eye because of its stark angularity, was a monolith; a black obelisk marking the entrance to a vast crypt.

Did a rush of storm-wind usher me towards the gaping entrance? — or has the memory of my short journey to the abyss been wiped clean? No matter: I found myself suddenly poised at the entrance, the broken and rotting steps crumbling down and away into pitch darkness.

Beneath the numenous shadow of the black obelisk I made my way down precariously, mortally afraid, at times horror-frozen by the stifling weight of darkness all around me. An eternity seemed to pass in slow descent, fingers sore and knuckles

scraped of skin, feet arched tensely like the claws of a frightened cat, teeth gritted together until my jaw ached and my eyes watered. And then — did I hallucinate a sudden amber flare? No, there were more: torches burning down in the bottom where the inky blackness once more changed into pallid twilight.

After another aeon of painful descent I reached the first of the palely burning torches where a hooded figure waited for me, silent and inscrutable.

I was led out of the devastated rim of the pit into the vast crypt below where labyrinthine passages, flagged by colossal stone slabs, connected a seemingly endless series of curtained cells. After a short time we arrived at one which my guide directed me to enter. Pushing aside the rough, sack-like curtain, I passed into a narrow, grey-brick chamber with a raised dais on my right and a niche on my left, upon which sputtered a thick, crudely carved candle. Over the dais was a short wooden shelf upon which rested a single book which leant precariously to one side, causing the mildewed pages to fan-out, frozen into place by dampness and time. For a long moment I sat in puzzled meditation, attempting to gather my thoughts, my attention naturally focussing on the candle; the single source of light and comfort to me. And it was as my eyes were drawn increasingly

to the candle that I noticed a grotesque shape in the niche behind it, which at first I had taken to be the candle's dancing shadow, but which upon closer inspection was seen to be solid and unmoving. Sliding the candle to one side I examined what turned out to be a statuette or effigy of a kind I had never seen before, though it was in parts driven with crudely fashioned nails like the fetish dolls of Africa. There was, however, nothing remotely humanoid about this eidolon, which was a monstrous composition of squamous traits and blackened angular surfaces, vaguely crystalline as far as I could discern in the half-light, with various appendages in the semblance of wings and rudimentary tentacles, the whole of which presented an appearance of utmost absurdity, and yet I was wholly impressed with a sensation of utter, cold dread; with an emotion of abject despair, so vast and loathsome as to be completely overwhelming.

I slumped back on the dais and shut my eyes with a revulsion of the spirit I had never before experienced.

I suppose more moments of bewildered meditation and anxious pondering occurred, but this passage of time exists in a gulf of amnesia. The next thing I knew, I had apparently removed the book from its shelf and was leafing through its age-damaged pages under the light of the

shrinking candle. Here were damp, smelling plates of figures I could not decipher, and crabbed hieroglyphics which lent themselves to no interpretive hypothesis. I pored through the hundred or so pages time and again, yielding no comprehension, but instead being instilled with a growing sense of unease, the very darkness at the light's perimeter seeming to gather like storm clouds.

With a conscious effort I shut the book and replaced it on the shelf. Then I closed my eyes; fatigue was beginning to register along with various aches and pains, and I craved sleep. Before long, I began to drift, and indeed I must have fell to dreaming because it appeared that the book's cryptic sigils had transferred themselves, like afterimages, onto the screen of darkness before my eyes, and were there squirming and shimmering with life and sentience, growing larger, forming distinct identities and appearances which were uniformly hideous and obscene — white, ectoplasmic imps and satyrs, succubi with barbed appendages like fluke worms, things that were meant to crawl but which could fly. I jumped as I sensed these nightmares were about to descend on me, crying out in the darkness. The candle had burned-out and I was caught in a net of pitch blackness.

However, a split-second later, the heavy curtain was swept aside and a hooded figure with candle in hand beckoned me to follow him without ceremony.

I was led through the dimly lit passages by my guide without meeting another soul. The silence all around was complete and eternal, like that of the deepest sea-bed. Finally we came to another curtain which the hooded one held aside for me, and which on passing through I staggered to behold a vast, grey-walled chamber with a brass-coloured centre dais, upon which a giant black column had been raised, dwarfing the shadowy figure who gestured for me to come forward.

Then the first words I had heard in that place were spoken to me.

"I am the Messenger," said the shadowy figure, "and the obelisk you see before you disappears to its apparent pinnacle in the dark skies above the rim of my tomb, and its trunk pierces through the very heart of this circle, and its base, ah — the base lies everywhere, in all times everywhere; in the same place everywhere; at the centre of All things everywhere. . ." He laughed, mockingly, and I looked up knowing before I did that the black obelisk would tower upwards out of sight, seemingly without end — because I knew it was the same obelisk I had seen before I entered this place, which cast its

noumenal shadow over the lid of the abyss, and I knew the Messenger spoke the truth.

I sank to my knees.

"You are Nyarlathotep," I said. There was no answer.

WHEN I AWOKE with my wife sleeping soundly beside me, my heart gladdened. I lay in the dawn-light contemplating my relief — but it wasn't long before I began thinking of that place again. I knew it existed in reality, and that I had not merely been 'commonplace' dreaming; rather my dreaming-self had visited a place it knew and had always dreaded, a place which my waking-self would not go, but of which it had always had knowledge through subtle awareness of its counterpart's unspoken message —

". . . everywhere. . . in all times. . . At the very centre of All things. . ."

The dream is the messenger himself. And the black obelisk is only one single limb of His daemon-master's infinite appendages.

Dungeons of the Soul

1. "HELLO"

AT HER OWN request, Anna had taken the wheel. She was driving in her usual careful, efficient manner, nipping past lumbering lorries on the wide expanses, and snaking over hillocks in narrower passages where the road was hedged with trees and flowering bushes. As the overcast slightly lifted I felt myself getting tired, and before long I was dozing. I thought of nothing and remembered nothing, and after what seemed like a long time I heard Anna say, "I will be careful who I choose as my servants — only the most worthy." But of course she hadn't said that at all, I had been dreaming again.

Full consciousness returned as we pulled into a tree lined lay-by where there was a dilapidated double gate which fenced off a ruined, cone-shaped mill.

After eating a few sandwiches, Anna and I ventured beyond the fence through the still-damp undergrowth to have a closer look at the ruined structure, beyond which ran a weed-choked, sluggish stream. By this time, the sun had come out, and dark shadows were cast in the dilapidated interior of the mill which was windowless and doorless, though scraps of boarding lay rotting here and there amongst the ripe weeds, exposing gaps of ruined brickwork.

"Do you fancy going in there?" I said.

Anna took my proffered hand. We stepped over fragments of debris, bricks and shards of brightly coloured tiles. Gloom was cast by the sun filtering through a series of partially destroyed or demolished upper floors and ceilings, giving the effect that one might be peering up to the surface of the world from the bottom of a dust-dry well. We examined the dingy interior of the building excitedly, like two careless archaeologists, turning scraps over with our feet, and scrutinising the earthen floor for items of interest.

Then, in the shadowy extremity of the darkest corner, in the remains of the kitchen fireplace, I found an assembly of plaster figures, each one just over a foot tall, gaudily painted, each possibly representing some saint or holy figure, but each having such a debased, almost feral, aspect, that I recoiled in horror — breaking one of the figures in my haste to put it down. Anna came over and examined the mannequins with wide eyes.

"These things are just horrible!" She exclaimed. Then, holding it up to the dappled, filtered light, she grasped the upper-torso of the figure I had broken and examined it in detail.

"What a cruel, dark face he has under his cowl," she said, "he's wearing a breastplate too,

do you think he's meant to be a knight of some sort?"

"I don't know," I answered — and then a little pathetically: "Do you mind if we go back now, Anna? I'm beginning to feel cold in this chilly place."

"Oh yes, of course — I wasn't thinking. Let me just count how many of these things there are. . ."

Anna counted to five, rather pedantically touching each of the figures with an outstretched finger, then gently positioning them so that the one I had destroyed could be supported by its more able-bodied fellows.

Later, as we drove on and I relaxed a little, I allowed myself to think about the weird figures, having to fight hard to suppress a shudder.

"Don't you think those statues were the strangest things you've ever seen?"

"I certainly do," answered Anna, "I wonder what the hell they were doing there in that place, amongst all that rubble! They were too horrible to be children's toys that's for sure."

"What makes you even consider it?"

"Oh, you know how children like to make dens in secluded places so that they can hide things from prying eyes — perhaps things that have been forbidden to them. Guilty secrets!"

Anna chuckled at this last phrase, making me realise how

deadly serious I had been about the whole episode. Still I couldn't help feeling uneasy as once more the sun disappeared behind a continent of iron grey clouds. Sure enough, moments later it began to rain again.

2. "I'M HERE"

THE NEXT morning I felt well enough to get out of bed, after an almost sleepless night of illness. My appearance in the kitchen startled Anna.

"I was just about to bring up some breakfast for you," she said, "You shouldn't be up."

I laughed, taking a pinch of snuff which made me sneeze violently.

"I feel much better today. We ought to be thinking about getting away for a few days; Doctor's orders!"

"Yes, I know," said Anna cheerfully; "I thought we might drive up into the lakes. I've made a few enquiries; there are some nice gardened cottages for rent at this time of year. . ."

The breakfast was laid out next to an unfolded morning paper the colour of impure wax in the sunlight. All the night's dark hours I'd spent in feverish relentless dreams seemed to melt away at this sight; that and the silhouette of wind-battered roses beyond the window pane. I looked at my wife's shining hair and her talkative, smiling mouth framed by banks of sun shot, racing clouds, and clusters of flowers.

"What are you thinking about, Robert?"

I took her hand.

"I'm day dreamy aren't I? Although that's much more preferable to the dreams I had last night. . . Anyway , I think we will go to the Lake District, I think it's just the sort of change I need."

Preparations were made through the day, Anna insisting on doing all the packing and most of the rest of the work, while I tried to keep out of her way unless she needed me.

Late in the afternoon there was a sharp, heavy shower which cast its stormy shadows into the house. I had taken my book to the window to catch the fading light, keeping half an eye on the rain as it began to drive against the window, when Anna called me from upstairs.

"I can't find the little silver crucifix you bought me," she shouted down anxiously.

Without warning, I suddenly felt that eerie sense of foreboding which is accompanied by some statements or events; that little coil of the brain which makes one feel that reality is a hair's breadth out of order.

"It must be here somewhere," Anna was saying, "you haven't seen it, have you Robert?"

I realised I had frozen speechless at the bottom of the stairs. The spectral image of a pale face

with dead, hollow cheeks and shrunken black lines for lips had replaced my own, and I couldn't let Anna see me this way. Then, just as quickly as it came, the hallucination — for that is what it must have been — faded, and I was ambulatory, and once more in control of my vocal cords.

We never found that silver crucifix, but a little later, when the rain had stopped, I stepped out for a short walk, thinking some fresh air would do me good. The drainage is always poor in the square and it was partially flooded, covered here and there with grey and buff coloured puddles glinting in the dying sunlight. As I passed several tall trees, I saw a man leaning against a wall at the entrance to an adjacent narrow lane, his shadow broken in two at the waist. I nodded to him, but received no acknowledgement in return, or any indication he had even seen me. At that moment, something caught my eye, glistening at the rim of a large yellow puddle. I stooped down to retrieve a small, tarnished silver crucifix, similar in every aspect to the one I had given Anna, except this one was scuffed, damaged and blackened. It was scored in such a way that the lesions almost implied scrawls and purposeful defacements. When at last I looked up, self-consciously remembering the figure I had seen, there was no one in sight and the dark narrow lane was

empty as far as the eye could see.

3. "GOODBYE"

THE WRETCHED man gazed long into my face, still holding me by the arm, slowly, very slowly, turning his head. I gently tried to move away from his fixed stare, speaking at last: "Well, what do you think?"

He was looking at me as fixedly as ever, holding up a finger. At last he moved to the mirror at the other side of the bedroom. Mumbling to himself, he took out his handkerchief.

"No permanent damage, my dear sir," he laughed, "though you'd do yourself no harm taking a long rest, plenty of peace and quiet you understand?"

I nodded.

"None of this gadding about here and there and everywhere," he continued obliviously, "that wouldn't do you any good. No, sir, what you need is a nice, long rest. Can you manage that?"

"I think so," I replied, "we've saved a little money, after all."

"Quite," he remarked briskly, "for a rainy day, no doubt! Well Mr Loring, it's thundering and lightning isn't it? Let's just say for argument's sake it's chucking it down with rain, sir. Yes, indeed it is!"

A violent shudder passed through me.

Dr. Locket left the room after standing before the mirror again,

mechanically straightening his collar, muttering in an almost inaudible tone to himself and whistling irritatingly between his teeth.

After a period of inert silence and solitude I began to feel drowsy. I must have slept for some time. I dreamed Anna, my wife, was attending me, singing a horribly grotesque song, the parody of a lullaby, the words of which spoke of 'a plaster face with sunken hollow cheeks'. When I awoke with a start I found I was alone in a room which was growing steadily darker as the day ended.

Infernal spirits, ghosts of the evil dead, observe the living as if through the bars of a cage, oblivious to their Eternal Reward, snared and trapped by some ineffable lust unaccounted for by any kind of connected hypothesis. They make their terrible oaths and burning conversions by the pale dead light of treeless highways, and when it would be far easier for them to intervene in our affairs for the cause of Good, they hammer at nails and pull at their course black hairs and fill their dark fields with blight. Like the ear-splitting roar of subterranean waters, they immerse the world in a ceaseless fury that expresses a deranged unwillingness to participate in life and a demonic refusal to die. They make their reachings out of the unknown at the expense of suns, sinking whole constellations into the treacherous fissures of eternal ice, only to perhaps steal one or two mortal lives from their otherwise routine destinies.

The Crawlspace

THE SUN was low as we passed along a dull waterside scene of mills and factories, most in disuse and decay. The whole area was touched with senility. Tufts of rank grass poked from the swampy terrain; rats crawled out of huge wounds in the crumbling brickwork; factory windows stared on dispassionately over the forlorn, stagnant water.

My companion unrolled the paper he was carrying. The extent of the decay, he pointed out, meant that many, if not all, of the surrounding buildings would have to be torn down for our purposes.

I began to nod in agreement, absently peering with half-slitted eyes at the decay in the twilight; it was like an elephants' graveyard; huge, sickly tombstones stood against the mist of the darkening sky.

I felt myself beginning to slip into the decay. The whole scene effected me with a miasma of unresolved emotion, fleeting glimpses of charred debris; green scum over bloated bubbles of dyke water; the unwholesome smell of bloodless fingers... these fingers clutched at my arm, shaking me free from an entanglement of cobwebbed visions:

"That noise! There, again: like someone crying out!"

"It's coming from over there, somewhere," I answered.

The shrieking sounded again, this time more like a low, grating moan. A shiver ran through my body. The surrounding decay seemed to close in oppressively; in the distance, the squealing of rat litters over the heavy slushing of dark green water and. . . Again, the cry; this time more urgent.

The scene we came upon was so grotesque I had to stifle a perverse impulse to laugh. Over a small, wooden waterwheel, a very old woman was stretched, her long white hair dragged into the water; spots of blood sprinkled from her nose and mouth into her eyes and, worst of all, her slight frame was racked agonisingly back against the shape of the wheel.

Before I had time to think, we were untying her, but it was too late: something in her back snapped; as we carried her from the greasy water she died.

But in her last moments, she looked at me and pointed to a dark mill on the bank.

"The. . . children. . ." she said. That was all.

I DON'T KNOW why I immediately ventured in there. I didn't even think about it. . .

THE PLACE was awash with stagnant black slime, but as I climbed the rusted iron stairs the rot and decay of wet was replaced by a musty smell of old wallpaper. Finally, I came into a dusty warehouse.

There were strange geometrical patterns on the floor of the room where I found them. . .

Broken glass lay all over the floor. . . A smell of urine in the dimness.

In the corner, a dark shape appeared. On close inspection I found it to be a statuette in the shape of some kind of amphibious creature, hideously bloated, with rows of bizarre little heads. Even though it was too dark to see properly, I couldn't take my eyes from the object, though I trembled nauseously and dared not approach any further. I was perspiring and my finger-ends felt white and numb. An atmosphere of sickening violence pervaded the warehouse, stifling me. I couldn't move, other than to rub my hands together; stomach churning, livid pinpricks of heat before my eyes.

THEN, I HEARD a movement behind me.

I turned around slowly and saw, through my nausea, a small hand appearing from a space in the floor.

In flashes of pain, I approached very slowly.

IT WAS A CRAWLSPACE be-

tween this and the lower floor. In it, two children, a boy and a girl (twins, I thought) sat very still, eyes closed.

I cannot explain it, but the darkness around them seemed to be filled with movement. It visibly crawled and formed strange blotches, like clouds of tiny flies. The crawl space was filled with the stench of excrement. A tangible violence hung in the air like a slaughterhouse full of rotten meat. Even so, I peered in further.

I thought I'd put my head into a hothouse; a sort of cloying, stagnant heat flooded over me, and in the darkness I screamed out loud as something touched me and at that moment the children turned toward me.

Though recoiling, my limbs kicking involuntarily like twitching nerves, I saw that their eyes were not merely shut tight, but that their eyelids had been stitched together. As the thing in the darkness formed itself before me, I realised the children's eyes had been stitched tightly shut so that they might never see what the blasphemous old woman had called up from the depths.

The Secret Place

THE DESIGN over the doorway was like the gaping jaws of a wolf, red slavering fluted stems twisting upward into darkness.

Above my head, aware of the night, I let my eyes roam dreamily over the obscured letters of the portal. Lights like fire, very far away, sputtered in the wind.

I tried the door. It wouldn't move, so I put my shoulder against it, shoving with my eyes averted upward in silent prayer, lest I should be discovered.

(Sweet, childlike face; blonde, fine hair falling in the breeze from the river — this: my conception of you — my own god's visage. . .)

Prayer ended, I entered the ebony slit between door and frame as the foundations sighed. The first thing I noticed was the ticking of the clock.

A cup, half full of cold tea on the draining board reflecting darkly into the stainless steel.

I rummaged in the drawer for the potato knife (reminded of having my finger- and toe-nails clipped by the fire, seeing my little porcelain bath with the painted roses, and dreaming that night of being peeled alive with the potato knife. . .)

I couldn't bring myself to put on the light. I dallied by the switch for what seemed like hours. The cracking of the staircase in the night broke the spell — I made my way to the bedroom.

It was so hard, trying not to laugh as I scaled the staircase. There, on one of the steps, lay a large rusty key in the dust.

— Just like me to have such luck! I exclaimed, knowing the key would fit the box.

The blinds were drawn in the bedroom, capturing the remaining heat. The thick, dusty darkness added to the exquisite thrill of our encounter.

Hands in the box as soon as the lid clicked to spring open; hands and fingers on your choicest parts, lovingly touching your fragile jaw, your fine yellow hair.

I smiled, reminded by your touch of the parts of a broken doll.

Oh god, how I love you.

The Human Snail

EYES EATEN away by dust, crawling with ants; armpits itching with blistering skin, he still sleeps as he walks.

The rubble beneath his feet, surrounding him like tatters of skin dyed red by the sun, fading into dimmer colours; his tongue is bloated up like a dry stump. There is no rhythm to his walk; his feet, his back, are cracked like leather. Ants on flakes of skin, stinging, trying to find a burrow to make a nest. . .

No moisture in his eyes at all; his hands hanging like the hands of a hanged man; legs shuffling like a walking mummy. . . the sky is getting darker and he must climb the steep slope. . . he cannot see past the mist before his eyes. . . blurred. . . a memory of a previous town. . . a man, lying in a puddle of mud with a small, black bore-hole in his head, his jacket ripped from his back and his skin, toasted and sizzling. . . tongue oozing green slime. . . vomit on the street. . .

Half-way up the slope, he grabs onto a huge slug, throwing himself backwards in a panic of wild arms, tumbling back down into the dust. Spitting flakes of dried skin, he starts to climb again. This time, as he reaches the top, the sky is like a tomb-lid.

IN THE HOUSE, holding each other close, the lovers saw his shadow blotting up the view.

HE MADE his way to their light — moths shrouding him, tasting blood, emerging from the holes in his hardening flesh.

They turned off the lights. Out came the sun again, shrivelling his eyes to stumps; like a snail, frothing in salt, only his shell was left.

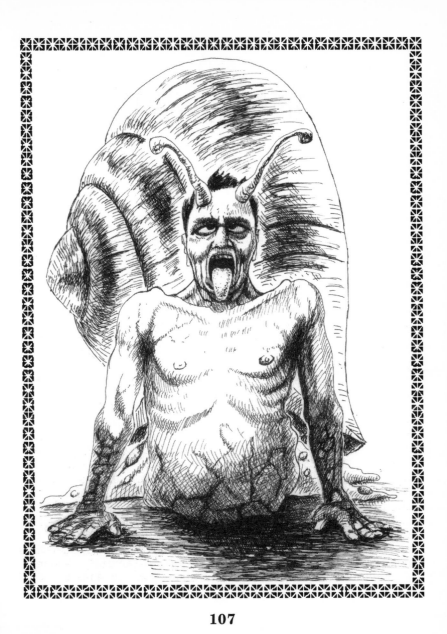

107

The Sea Visit

"WE'LL WALK this way," he said, "the cliffs offer a fine view of the ocean."

"Good," I said, "how far away are we from the house now?"

In truth I was a little nervous. The light was failing and already the sun had mellowed into a deep red, like the eye of a great beast. I stared ahead, feigning indifference, but really I wanted to get back to the house before dark.

"There's plenty of time," he said, guessing at my anxiety.

At that, I followed him in silence up the winding path to the stone steps that led onto the green cliff tops.

Here, the air was fresher, and yet, as it always is with the smell of the sea, somewhat rank and distasteful. I tried, however, to bury my doubt and enjoy the scene.

Below us, the panorama of the coastline seized the eye in splashes of vivid oranges and reds. The blinking eye of the sun melted the far images and curled its reflection into the turbulent water like a torch shining into darkness. Here and there on the limestone paths below, scraps of litter blew and seabirds picked at picnic relics.

He turned to me, with an enquiring, expectant expression. . .

"Yes, it's beautiful; very beautiful indeed," I said by way of an answer. At this, he seemed more

satisfied, and I wondered to myself whether now he would allow our return. Some children passed by on the path below, setting off on a darting run. After this, silence.

"I'm going down a little way," he said at last, "are you waiting here for me?"

I murmured: "yes."

It seemed to me then that the whole pattern of events so far, was like a configuration; a fulfilment on an astrological chart made many years before, as all the movements fell into place generating the final outcome:

It was from the sea itself that it came; below the reddening horizon, at first just a spot of dark grease. I could make no sense of it at all, but I could not call out, or even move. . .

From the stain, the thing began to move, uprising from the waves in a slow spiral of muck and seaweed. It was a huge black stone; a black standing stone, an obelisk, dripping a tarry black substance in a vast stain into the sea storm its movement had created.

My eyes cracked with sudden movement; I felt the slow movement of blood within my nasal passage. In a second, the clot began to stream from my nose and I coughed awkwardly, moving back and forth, doubled over.

A few seconds passed like this. Then, I felt his hand on my shoulder as he led me from the scene.

"Come," he said, smiling calmly, "we shall return now."

"I Control You"

IF I WANTED to I could come before you like a Vision of Glory. I could descend upon you in a rush of wings and glamour. You would be fascinated by me in an instant, but you would pretend to believe otherwise, and this would be my protection. I could very easily manipulate your every move, because you would refuse to believe it possible. You would not admit that I had power over you; this would make you feel ashamed. Instead you would pretend *my* orders were *your* insights. Like you are doing now! You're fascinated, but you're defensive; sneering; unbelieving; not convinced. That makes it very easy for me. I can get you to act without trouble. When I am in your presence you hardly recognise me, because I am quiet, undemonstrative. I am beneath your notice, but this makes my speech subliminal and it makes my orders acceptable, without argument. Because I don't shout or make any big noises about myself in your company, you can relax enough to let your natural arrogance shine through. I, of course, remain nervous; on edge. I say little; and what I *do* say seems trivial! You assess me: I don't seem important.

I lack confidence; I'm nervous; I'm polite and I respect you; I'm impressed by your knowledge. You don't feel the need to invite

110

me again because I'm not a threat or a challenge. But don't feel so safe now that you've "sniffed me out" and "weighed me up" because I'm still here with you and that's the only reason why you don't know where I am or what I'm doing: how could you know what's in your own mind, when it isn't yours to know anymore?

I can do this to you and I have done it, but I won't brag: you're embarrassed and angry enough for now. I'm not stupid enough to give you a chance to escape my power. Why should I? — You don't believe me about this anyway, do you? I just make you defensive and angry. You think I'm foolish to make these claims — defensive again, aren't you? — You think I'm just trying to out smart you. That's alright. I'll let it go at that. It's the easiest way out for me. I can always come back later when it's gone quiet again.

Hair

THISTLES OF HAIR strangle my entwined fingers in a knot of pain; I try to distance myself from the madness of the moving tendrils of hair, I try to unfurl the clinging strands from my tongue, from the broken red lids of my eyes.

If only I could see.

I spit a vortex of seeds from my aching mouth; seeds like dandelions, winged like craneflies, beating against the wet stones. When I throw myself back against the cold wall, voices pierce into my ears; voices of hair that mime the words of otherworlds, like soft distressing pleas for help.

The hair! The hair which entangles me is the hair of plague victims, the long hair of drowned women thrust up from the water to drag me down, their foul seeds polluting the water; forming larvae that takes wing over the enclosed earth, spreading disease and fever.

This hair knots up my tonsils, flakes down my nose and grows vile shoots in my torso, from where, impregnated hourly, the seed conceives a new form to torture me, a new constriction of birth; the emergence of a flood of grey-yellow hair against the slime of walls like an explosion of moss. Lines of sores. Hair growing into the pores of my face in this utter darkness.

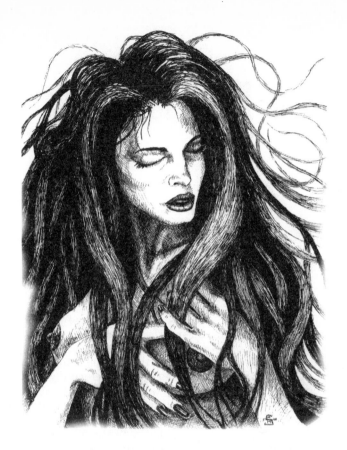

Lips of hair part my flesh and rebound pain into cancerous growths that seal up my ears. In a paroxysm of suffocation, I furl-in my disjointed fingers like a dying flower; I crumble inwards into a ribcage knotted by hair.

When you open the door to my pain you will see a knotted tangle of hair like dead snakes, a mournful growth of mouthless agony. When the muffled door of my putrescence is opened, you will feel the balls of hair under your eyes; growing beneath your skin, through your veins, under your fingernails.

The void is sealed by the hair of death; all space is the shifting void of hair.

113

The Black Idol

GRAHAM EVANS found the little statuette in a hollow tree. It was behind a large thick spider's web that made him shudder as he broke through it with his shaking fingers. The experience was like parting filthy, matted hair. . . dead hair, splitting off into dust motes. When Evans first felt the thing, his fingers recoiled like the legs of a spider. It was cold and pulpy, like smooth-skinned fruit. When he pushed his hand in again, this time retrieving the object, he found his first impression had been wrong. Though it was indeed cold, the object was not pulpy at all; it was as hard as marble. Evans could not account for this initial sensation; it must have been due to his horror of the oversized, enshrouding web — that would account also for the object feeling like the pulpy body of a very large spider. . .

EVANS HAD moved into the house a few days previously. His first impression in this case hadn't been wrong: the house was definitely creepy and cheerless. However, he was much nearer to the town now, and he had the convenience of being almost isolated by the coppice that sectioned the house off from the main street.

The garden was rambling and desolate with weeds. The polluted pond was overgrown and most of the colourful flowers (Evans did not know their names) were choked in an entanglement of nettles. Evans hadn't intended to explore the garden until he had settled in the house, but as he moved restlessly from one room to another, his eye was constantly caught by the garden jungle. Finally, he made his way outdoors into the soundless, shadowy undergrowth. That was

when the dead tree had caught his attention.

NOW IN the kitchen, he studied the delicate statuette, shuddering, turning it in his fingers, not sure whether he liked to touch it or not. He couldn't work out what it was meant to be. It resembled from one angle, a stylised spider; from another, it was more like an ant. . . but the overall effect was not somehow as abstract as its shapelessness suggested. Evans knew it was an idol of some kind; it looked African, or Oceanic. The elongated head was mostly a large, ovalled mouth, lined with jagged, mandible-like teeth. The suggestion was of an entity (how else could it be described?) reared up in a position that seemed to mimic the holy relics Evans had seen in picture books. The shape became more and more humanoid as he studied it. Shuddering once more, Evans was amazed by all the precise detail. The object was no more than five inches tall. It was as black as midnight.

IN A FEW days, Evans had cleared up most of the house — though this meant merely sweeping out many rooms before lighting a fire to ward off the damp. Sitting downstairs, Evans meditated cheerlessly about the expense of renovating the decaying building. He sipped at his whisky. . . why had he bothered pouring himself a drink? He scarcely enjoyed the taste of alcohol. He gazed into the deadening embers, into the blackness of soot behind the fire grate. . . where had he put the idol? Which room had he put it in. . .?

OUTSIDE the cold windows, night and rain gathered. Evans closed the heavy, brocaded curtains. He mounted the creaking stairs carefully, mindful that a few days ago he had slipped on the loose boards. He would put on his slippers, he decided, and then go and look where he had put the thing down. He realised he hadn't seen it at all that day, and he was becoming accustomed to looking at it for a few minutes, every hour or so. He would like to find it now, so he could look at it again before sleeping.

Evans winced into the mirror at his worried, forgetful face. He pulled on one slipper, then another, and suddenly cried out, kicking the slipper off, where it fell heavily against the door. The little black idol rolled out.

"NOW WHY did I put it inside my slipper?" said Evans stupidly.

He picked up the object, with a look of loathing on his pinched face, turning it in his fingers; placing it on the dusty dresser

and studying it from mid-distance, picking it up again, touching the mouth with a fascinated shudder. It must have been the light in this room; Evans wondered how else the idol could have appeared to have closed its mouth.

DAYS PASSED very slowly, all with the same grey, wintery colour that betrayed the rainy humidity outside. Inside the house, Evans was cold and hungry.

THE IDOL had begun to open and close its strange mouth with increasing regularity. Eventually, Evans detected a pulsating, machine-like noise issuing from the object. It was talking to him. He decided to try to understand the vibrations the thing whispered into his ear. Like all weird idols, he rationalised, it must be demanding a sacrifice. Evans' opportunity to prove himself came sooner than he thought.

That afternoon there was an urgent knock at the door. Evans crept from his bedroom, wrapping a robe around his body. He stood at the top of the stairs, heart beating rapidly. The knocking continued. Evans opened the door.

"Good God, Evans, you look terrible! You were supposed to be back at the office last week and I called to find out why. . . well. . . it's obvious isn't it? You look terrible, what's wrong with you?"

"I don't know," said Evans.

"Can I come in, then?" Evans stood back to let McDonald in.

"Do you need anything, Evans?"

Evans plunged in before he could change his mind, though nothing could stop him shaking from head to toe.

"Yes, yes Clive. . . the secretary. You see I've managed to finish — to *nearly* finish — some work I'd like typing up. . . do you think you could ask her to call around for the stuff tonight. . . or tomorrow morning if that's inconvenient?"

Evans' heart leapt as McDonald halted momentarily. He frowned at him, but then his face softened. Evans let out a barely disguised sigh of relief.

"You shouldn't have been working in your condition, you know," said McDonald, "I'll send Angela round to collect your work in the morning. Anyway, take care will you? — and get some rest."

"I will," said Evans.

ANGELA WAS against their union at first. That was to be expected. Evans had to coax her into the house — "Come into my house, said the spider to the fly," he had thought nervously — but that was the easiest task because he looked so ill. The hard part was to get Angela to look at the idol; to touch it.

She was sick several times. Finally, Evans used all the nerv-

ous energy he could muster to force Angela to hold the thing. Once that task had been accomplished, Evans was astonished to see how rapidly Angela's demeanour changed; how eager she was to offer herself to the idol. In the dark, damp bedroom they crawled all over each other like spiders. The idol stared on fixedly, discharging its poisonous vibration into their heads. Numbly happy, Evans was glad to see Angela voraciously throwing her head back, laughing almost gleefully. He felt the idol's primitive consciousness finally taking over his senses. As he abandoned himself to their sex act, his trepidation caved in like a husk. His orgasm reached the heights and the depths of primitive violence. The idol had given him Pure Essence in return for his sacrifice. When it was over, Angela's body lay deathly still and Evans felt himself returning to more orthodox dreams as he slept.

A FEW HOURS later, when he awoke to find Angela gone, a grim realisation gripped Evans' heart. Something about the *female* of the species. . . but surely their coupling had been a poetic one; a metaphor of the black idol's gift. . .? Why then was he unable to move, stifled by a sticky mass of ropey ichor. . .? . . .the whole of the dusty room was filled with Angela's sticky, vibrant web. Evans began to scream, but his mouth only emitted a pulsation of machine-like whispers.

ONE DAY when representatives of Evans' insurance firm called at the house, they were startled by a strange face staring at them from the back bedroom window. They walked nervously up the broken pathway and found the house door ajar; a series of dusty strands led up the staircase to the second floor. The house looked as though it had been abandoned for many months and the gentlemen were keen to discover the whereabouts of Mr. Evans, who owed them money.

As they came to the second-floor landing they could hear a great deal of commotion coming from the back bedroom. In their haste and nervousness, they kicked against the bedroom door, causing an unfortunate accident.

WHITE WITH HORROR, they saw the thing that was once Angela as her bloated abdomen burst from the impact of the door. A flurry of slimy legs issued onto the dusty floor as she screamed in pain. Each of the infants was no larger than the strange black idol that rolled out of their dead mother's hand. . .

In their race to leave the building, the insurance agents did not see the half-obscured body of Graham Evans, mummified, dry as a dead tree trunk inside layer upon layer of thick spider's web.

Pulped Fruit

THIS DREAM of mine is moving me through cupboard spaces. In all events, I am slowly smothering. After nights like these, it's not surprising I choose a few quiet moments to reflect upon a mental claustrophobia that threatens to pulp me in its jaws. . . Night is mainly a memory of endless rain, full to bursting, like a rich fruit, rotten with the idle inspection of its polished skin. Flakes of mould excaserbate my images, as tactile as the damp stains on the curtains. . . In bed I reach out with my mind, as I have been instructed, trying to touch every living thing; every creature that swarms beneath the sun and the moon. I attempt to mould myself into every form I encounter, sigilising my soul; forming a rubric of "all life itself" — still, I am convinced of my isolation.

When I sleep I dream about a cobble stone hill. I am walking up and up, labouring against a strong, cold wind that blows against me. Objects flood my narrowed eyes; paper, tin cans and other rattling objects. In an instant, one of these objects cries out, like a despairing old woman. Tumbling past my shivering, outstretched arms, a priest, a monk, rolls by on the jagged road, leaving a trail of blood and an arc of spittle that sticks to the turbulent air, forming a fluid picture.

I stare at this, until I can make figures out, emerging from subtle pools of saliva like foliage. Most of the figures resemble winged trees, with gnarled, half-formed faces and roots for fingers. Then the image bleeds all over me, bubbling in a halo. I become drenched in the saliva. At this point a dark transmogrification takes place. . . I stare solemnly into the vortex of a black cylinder whose narrowness disappears into a point, far away, spinning in a web of space. . .

That's only part of the dream. I may be able to remember other instances from further back.

It seems funny to me: my attempting to be profound draws the deepest ridicule towards me. (There is no one here but myself!) The air that I whirl with my outstretched fingers forms a companion out of the dark shadows in the endless passages, whereby I am led from point to point over an abyss of derision and laughter.

The Fingers

THE WILD EYES of the boy trail over the old trees. The room smells of his spilt seed; hoardings of dark blotches upon the damp walls. . . like women's mouths. . .

In the room below a baby cries. He has a vision of spiders encircling a derelict church where a dead man's tongue rolls out like a bloated red carpet that flies breed on.

He laughs. The dead woman on the bed is a sea of limp flesh, wobbling about. Her expression is reflected on the silent windows, crawling about furtively in the trees. A spot of thick blood puffs up from her left eye. He wipes it off, almost carefully.

THE TOILET SEAT is cold. The carpet is murky and damp beneath his feet. Pipes hiss impotently as he turns on the taps over the sink where he has placed the dead woman's head. He is rinsing the blood off in preparation for removing the nails from the skull. It's a difficult job.

His mind wanders. . .

IN THE REMOTENESS, he thinks of his enemies. He leans on the mossy wall, like fur down his throat; coughing deep down to his ribcage with the voice of the woman. His memory of the train is silent, moving through the trickles of her blood; emerging from the shadow of her pursed lips. The blinding, shadeless light bulb has defeated her eyes. She has transmogrified into a corpse; the rotting skull, full of iron. . .

The memory of his knife tearing at her gloves (. . . get. . . your. . . hands out of the. . . way)

like piranha's teeth on her flesh. . .

WHEN SHE screamed, he kicked her again and she screamed much louder. She saw his face so he put his knife in hers. . .

"How do you like that?"

He handles her head like a doctor, lifts up the lips and lets them slowly curl back like petals of a dead, rubbery flower, almost rigid and black. Her incisors are prominent, covered in dried phlegm and spittle and hair — flecks of skin and blood.

A siren floats by, momentarily lightening the room. He has a vision of a tunnel. Cats howling in the graveyard, fur matted with the blood of dead birds, tearing wounds into their sullen expressions.

The woman's head had come off easily. Her flesh tore like polythene under the water; a feeling of spilling something that would emerge later in the cracks of the walls.

HE POKES about for the blackened tongue, feeling the cotton wool strands on his fingers as one by one he draws the million sharp needles out of her brown scalp. There he reaches. There, he finds her hanged man's tongue lolling like a dog at play. A smile comes to his lips. . . Play dead, he thinks. He says to himself: this is only the beginning.

Then, all these thoughts dry up inside him. He has difficulty deciding on their reality.

Perhaps it is many years after. He is much calmer now. Miles and miles of seashore sand; brine in the night air and his pockets full of shells. His awareness is dulled by happiness. He rests his head on the surface of the wet sand where the dead woman's head rests leagues below. He must gather his thoughts — he must *think*. . .

How many? How many years ago?

The fingers he holds up against the moon to count! The fingers, broken and mutilated against a vague dream.

THE BOY SMILES. It must have been a dream. It's all coming back now.

He remembers the violent struggle with his fingers. He remembers the dream as it came to him at the instant her tongue lolled out.

It was like slow motion; the buzzing of flies and the unutterable pain in his hand — looking down, looking down at the head nodding comically, eyes open, rolled up. The crisp cold mouth biting down upon his fingers — the jangle of nails in the running water and the din of the house in the rain.

121

The Black Pyramid

I WALK TOWARDS the house along the steep, pitted driveway, enclosed by knotted branches tens of feet high. The sun is low behind the house; it seems to crouch like a cowled figure over the pond with its ornate figures and calcinated shrubbery.

(Something floats dead in there—drowned).

Perspective distends and then contracts. Dizzy for a moment, I find myself before the door. I trace a crack in the panel with my finger as though to announce my presence to the occupant.

Inside the house a bell is chiming. I hear the sound of heavy footfalls and the creaking of the staircase. The door begins to rattle on its hinges and the letterbox squeaks open momentarily. Finally, the door is flung open and the old woman stands there irritably, clutching a rake in her left hand.

"Remove all the leaves from the surface of the pond," she announces.

I SET TO WORK, dragging the leaves to one end of the pond, taking care to avoid the thing that has drowned there. The job only takes a moment, but already it is raining and the wind has risen. I blow repeatedly on my knuckles, trying to generate some warmth.

I PACE UP and down for ten minutes getting wet. At last, I decide there is no point in avoiding the open door as it creaks in the wind. I enter into the musty confine of the narrow hallway, closing the door behind me as silently as possible.

I call out, self-consciously: "Hello! Hello! — I've finished . . ." No answer. There is a faint scratching sound coming from the low, badly stained door panel in the staircase.

I approach the panel tentatively, whistling as though to call to a bird trapped in there. Then, I start to tap on the door with my fingernails, hearing the hollow sound echoing upwards. Finally, I open the panel and enter into the darkness below the stairs.

At first I find the hollow world a strain on my nerves, but very soon I begin to relax. The dark passage goes up and up for a long time. Occasionally dead moths drop onto my head from fused or disused light sockets.

Little by little, light is forming. Finally I see its source is a narrow window at the end of the corridor. It only remains for me to open the window and I know what I will see — and there it is!—

The black pyramid!

And all along the route that leads to it, the fields and the trees and the flowers are suffused with a black, beautiful radiance like a garland of angelic haloes, all moving and lovely, as no ordinary sun could ever be!

I am enraptured. I leap from the window into the pyramid, and my breath is literally taken away. Foaming splashes of joy pulse throughout me; my ears are ringing with the most beautiful voices.

As I emanate into the radiant cone of black light, I see my body crash into the pond below, it's hand reaching out to clasp the drowned, floating hand that was once concealed by a surface of leaves.

A Vampire

THE SHEET I wrap myself in winds around me, embalming my dreams of once, long ago, when there was light. Inside my fist I hold myself, tightly: I am in perpetual fear of dying meeting the darkness in all its undiminished glory, the puttering smoke-factory of its belly in a toxic vision before I am, once again, no more.

To have emerged in this bleak silence, I am delivered in my waking hours. Meanwhile, in the sadness of dreams of sunlight, I weep, for I know now it would destroy me.

Through the gauze at my window, I filter the low green moon. Though the whole city may be its neglected offspring, still our reverence obeys gratitude for its pale source of light the source of identity and vision, however dim that might be. Too soft to penetrate the blackness of the night, first-born from it like a spark of green light from the womb. Too soft to feed the belly of self-recognition. Indeed, I have spoken of the river before. I also know that while we are forever in shadows, these shadows are inanimate; not ours, in fact. So too, the reflected light inside me cannot escape, and I do not cast an image. How can one who is dead do anything other than absorb?

By saying this I do not seek

your confidence or your patience. A tale recounted to mortals needs a certain adaptation. Comprehension is a maligned and overlooked virtue; I command the understanding of my audience, though because I have no self-image to bargain with, I am not tempted by fame or speciality. Within my darkness there lies the very absence of soul as you might know it; I am only an awareness, such as the substance of smoke is only appearance. I cannot reveal more. I have no power in this matter.

Still I yearn. A beast may impart the presence of absent identity to its kind, but since I am removed from all nature, I am not even that. I cannot sense beyond the abject feeling that being like this is both familiar and yet, foreign like an ancient city.

I digress. Now that my shade has formed its mass, I will speak hastily of a place that is formed in formlessness a city inside a dream; deep, empty, fearful. I will continue my story once more, I will speak of the city.

Nothing gleams. All eyes give off a dead light. Despite the outline of life such semblance as it is there is an immovable sense of fixture. It is like a tincture formed in a dead green vessel all the once generous properties have been drained by the movement of hours, and yet the liquid itself appears unchanged. In this exist-ence, where energy has reached its zenith in the imagination alone, the millions tread wearily between the crumbling walls and odorous skyline.

I am an aborted soul among many. Even so, as a predator I command certain reverence among the fearful and if others exist here, I do not know them. I inspire fear like the orbit of a dead star.

I do not give even that much radiance. The coiling dark rebounds within me like a ricochet, like years of dust against a dampened pillow. I am worm-eaten with self-possessed knowledge. Any sense of real identity pours out of me as though I were worm-riddled hence, I appear to describe my essence, when in truth, I have none to describe. I am only mediated darkness. I am the image of something without image. A vampire casts no reflection I am exactly that which I am not. See now, how meaningless your fear is, in me unidentifiable.

I wake, the vampire sleeps.
As I am lost in reverie I hear
his plaintive dream,
the impression
of his dark mind.
In this communion our souls
are sealed.
In this eternity, our shadows
cross and I see through his
grey, devouring eyes . . .

The Drowned Mermaid

I see your face
looking up at me
like the face of a beautiful
stone wall.
I see the shadows
on the waves
of your flood;
the ice in the fold of your fingers.
The empty threats
between each tooth
in your blue mouth;
blue, because the waves
are crashing out;
blue because your waves
wash my pale hair,
wash my white knuckled foam,
my dreams.
You are my ocean
lost in the water;
nothingness, like a bell tolling
beneath the waves.

I see your face
cracking open into light.
You pierce my hands

with your lightwaves,
with the pressure in my skull,
you most beautiful ocean,
most ocean-like flower,
blooming in a shrouded blue
beneath the empty waves,
under the gasping foam.

I see you — I see you
move under me like a wave
I see you
under me, moving
like a tolling bell,
like an edifice of cruel stone,
like a blast of winters oceans.

I see you
I see your face
I see you moving
I see your waves
I see your waves

I am the cruellest stone
to your bluest waves.

The Little Death, **The Fingers**, **The Crawlspace**, **The Repeated Journey**, **The Human Snail**, **The Black Idol** and **Xenos** all first appeared in *Xenos*, Sarcophagus Press, 1989. **In the Arena** first appeared in *Arcanum* No 1, Nox Press, 1990. **Exquisite Corpse of a Multiple Personality** first appeared in *Taking God By The Horns*, D. M. Mitchell, 1990. **Hair** first appeared in *Memes* No 3, Norman Jope, 1991. **The Fingers** appeared in *Red Stains*, Ed. Jack Hunter, Creation, 1992. **Beneath the Black Obelisk** first appeared in *Cthulhu Codex* No 12, Necronomicon Press, 1999.

— **Do Not Miss** —

PORTS OF HELL

by Johnny Strike

Jamie crossed a leg and looked at Elias, who was sitting across from him wearing makeup and a lavender turban. Elias was heavyset, wore a pencil thin moustache, had a shaved head and claimed he was from Lemuria. He had the most compelling pale blue eyes Jamie had ever seen...

Ports of Hell is a picaresque story that borrows from all the pulps including crime, science fiction, fantasy, adventure, horror and literary fiction.

Author **Johnny Strike** is the founding member of the seminal and influential San Francisco punk band Crime, whose songs have been covered by Sonic Youth and others. His current band TVH recently released *Night Raid on Lisbon Street* on Flapping Jet Records. He is a contributor to *Headpress, Ambit, Chronicles Of Disorder, Cover, Maximum Rocknroll* and *Si Senor.*

The Second Sensational Book

from DIAGONAL

Published: Sept / Oct 2003

ISBN 1-900486-33-4

William S. Burroughs said of **Johnny Strike** and **Ports of Hell** (in 1982): "Just got around to reading the pages you sent and was agreeably surprised, so much of what people send is just awful... If as I do you see the artist as a map maker then these are real maps of real places. That is what marks the artist, he has been there and brought it back."

Geoff Nicholson (prose editor of *Ambit* and author of twelve novels, including *Bleeding London*, which was shortlisted for the Whitbread Prize) continues: "I sometimes despair of finding good new writers, then along comes someone like **Johnny Strike** — fresh, tough, literate, surprising, and it makes the search worthwhile."

John Shirley (author of fourteen novels including the horror classics *Dracula In Love, In Darkness Waiting, Cellars and Wetbones*, the collection *Black Butterflies*, and screenwriter on *The Crow*) writes: "**Johnny Strike**'s novel shows us a writer with a future, part of the confluence of underground and genre influences that makes American fiction exciting. He has much in common with Charles Bukowski, but there is a flavour of Ballard at times, and a love for the exotic. I am convinced he will mature into a masterful writer."
